Collins

Learn to Draw

Comics

JOHN BYRNE

In memory of
Olga Pyke
and
Mrs Winnifred White

First published in 2001 by
HarperCollins*Publishers*
77-85 Fulham Palace Road
Hammersmith, London W6 8JB

The HarperCollins website address is:
www.**fire**and**water**.com

Collins is a registered trademark of HarperCollins Publishers Limited.

02 04 06 05 03 01
2 4 6 8 7 5 3 1

© HarperCollins*Publishers*, 2001

Produced by Kingfisher Design, London
Editor: Tessa Rose
Art Director: Pedro Prá-Lopez
Designer: Frances Prá-Lopez

Contributing artist: Leonard Noel White *(pages 13 bottom, 18, 23 top, centre, bottom left, 24 right, 25 bottom left, 32, 33 top,
34 top right, 35, 36, 37 top left, bottom left, 41 top, 45 left, 46 bottom, 47, 51, 55 bottom, 57 right, 59, 60 bottom centre)*

Text and illustrations for Tools and Equipment *(pages 6–11)*: Valerie Wiffen A.R.C.A.

A catalogue record for this book is available from the British Library

ISBN 0 00 413411 7

Printed by Midas Printing Ltd, Hong Kong

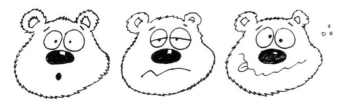

CONTENTS

Introduction	4
Tools and Equipment	6
Basic Shapes	14
Proportion	16
Body Movement and Gestures	18
Character Development	20
Creating Your Own Characters	22
Expression	24
'Human' Animals	26
Clothing and Props	28
Perspective and Foreshortening	32
Backgrounds	36
Speech Balloons	38
Lettering and Type	40
Special Effects	42
Creating a Grid	46
Creating Time	48
Story and Script	50
Developing Roughs	54
Final Pencil Drawing	56
Final Ink Drawing	58
Using Reference	60
Other Ways of Using Comic Strips	62

Introduction

Whether you're into action adventure or slapstick comedy, there's only one thing more fun then reading comics and that's drawing cartoons and comics of your own. That's what I've been lucky enough to do for nearly twenty years and that's what this book is going to help you to do, too. And even though I don't have X-ray vision or super mind-reading powers, I know that you're about to have a great time, no matter what kind of comic artist you want to become or whatever your level of ability.

I've split the basics of cartooning into a series of simple steps, the same steps that EVERY artist uses, whether the intention is to produce an intergalactic adventure, a talking animal story or even a fine art portrait. After you've tackled these basics, all you need to add is your sense of adventure, belief in your own creativity and a willingness to practise, practise, practise. Luckily, in the world of cartoons even the practice is exciting and fun.

However, the one thing this book can't do is practise for you, so rather than simply reading it from cover to cover as you would one of your favourite comics, arm yourself with paper and pen and make a point of trying all the tips and tricks for yourself as you go through. The end results may not look exactly like the pictures in the book, but that would be a good thing. After

all, if everyone drew exactly alike, comic art wouldn't be nearly so fascinating. Even if at this precise moment you're convinced you 'can't draw a straight line', a little effort will lead to a marked improvement in your artistic abilities. If you already have an interest in cartoons, it's always a good idea to keep your skills honed by looking at different approaches. In this book you'll find many new things to try.

Once you've kick started your cartooning skills, we'll look at lots of techniques and ideas for using your talents in comic strip form: how to come up with stories, how to develop characters, how to make use of a whole array of clever comic book special effects. From 'Peanuts'-style gag strips to epic super-hero adventures, all the tips and ideas you'll need to bring your own comics to life are provided. The only way to find out which ones work best for you is to try them all at least once. You might even discover a whole new area of cartooning ability.

At the beginning of my career as a cartoonist I was always drawing super-hero-type adventures, but as I played around with ideas I discovered a liking for humorous stories too. Nowadays most of my professional work is in the humour area. I have also come across highly successful 'graphic novel' artists who started their drawing careers in 'the funny papers'. Of course the great beauty

of a really good comic strip is that you have the scope to switch from humour to drama and back again whenever you wish.

At the end of the book we'll look at using comic strip skills differently from the ways presented in traditional cartoons and comic books. Perhaps you already have skills in some other area of art or drawing – a talent for sketching figures, for instance, or for producing animal portraits. You

might like to attempt combining these skills with the comic strip style, which will enable you to tell stories and create the illusion of movement in your work.

Whatever your style of drawing, whether it is highly cartoony or super-realistic, you'll find lots of ideas here to spark your imagination. Who knows, the next generation of comic artists may well be inspired by the stories you create.

Now it's time for your drawing adventure to begin. Look up in the sky: is it a bird, is it a plane? No, it's a super comics artist. I hope that by the time you've finished working through this book, that super artist will be YOU!

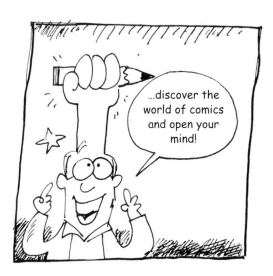

...discover the world of comics and open your mind!

Tools and Equipment

PENCILS AND GRAPHITE MEDIA

Types of pencil
Pencil leads contain a combination of graphite for blackness and clay as a binder. The greater the graphite content, the softer and darker the pencil. More clay gives a firmer point but sacrifices blackness. Pencils are graded: B for black and H for hard. Artists and designers use grades up to the softest 8B. H pencils are used for accuracy in technical work. F, or fine, grade is a black pencil with a durable point. Coloured pencils have a waxy content, sealing the paper, and are best used separately.

Using graphite media
Drawings made with soft graphite media above grade 2B require a minimal spray with fixative to protect against smudging. Grades B and F may be left unfixed, or sprayed lightly with clean water from a plant mister to set them.

Paper surfaces
Pencil points are hard to control on heavily textured paper, called Rough. They work well on papers with subtle textures, called Not, the smooth surface that is hot-pressed, or cartridge paper. Polished or glossy surfaces are unsuitable; the point skids, distributing graphite unevenly. Avoid soft-surfaced paper, too, as pressure creates grooves that are apparent after erasures.

Drawing effects

Fine and firm leads are best used lightly until accuracy is established; if you are too emphatic in pressing the graphite into the paper surface, erasing becomes difficult.

Soft pencil smudges easily. To avoid brushing your drawing, keep your wrist high; the alternative, to mask your work with loose paper, will obscure your view.

Technical pencil leads are round and sold in widths to fit the gauge of the aperture. Sharpening is minimal. The range of soft grades is limited, however.

Used sideways, graphite sticks allow you to cover broad areas and to make larger marks on the paper. Soft grades of graphite may develop helpful points or sharp edges as they wear down with use.

1 HB pencils, though too firm for expressive work, are widely available and retain their points well.

2 The F grade is recommended if you require rich tone combined with a fine point.

3 2B is the best average grade to use, because is combines tonal depth with a durable point and minimal smudging.

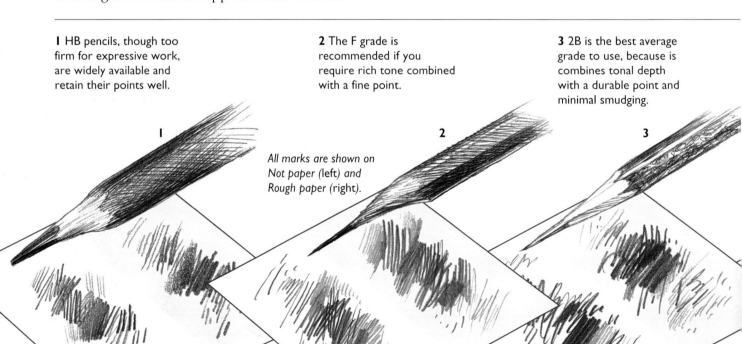

All marks are shown on Not paper (left) and Rough paper (right).

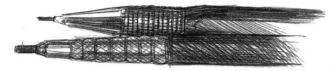

Left: Clutch pencil (*top*) and propelling pencil (*bottom*).

Clutch or propelling pencils

Clutch, technical and propelling pencils with round leads are convenient to use, especially while travelling. However, they are designed for making marks of a designated width and call for some ingenuity on the part of the artist to lend interest to their unvarying quality. Hatching, when areas of juxtaposed linear shading are laid parallel, or cross-hatching, when these are superimposed, enlivens their effect; as do variations of drawing pressure. Buy replacement leads in soft (drawing) not hard (technical) grades; see types of lead, opposite.

Graphite sticks

These resemble large-scale pencil leads without a wooden casing. The round-sectioned types are usually coated with sealer for cleanliness. The hexaganol or faceted types are lacquer-free and so they are best used wrapped in foil or paper which will prevent too much graphite transferring to your hands. Drawing with either type will eventually wear an edge which can be very useful for fine work. Both types of graphite stick come in all drawing grades from hard to soft.

Hard grades of graphite have a high clay content and make silver-grey marks which lack impact from a distance.

Use the broad side of a graphite stick to make bold marks, which are not possible to achieve with a pencil.

Erasers for correcting pencil

Graphite is easily erased provided it has not been forced into the paper by excessive pressure. Avoid gritty erasers that chafe paper fibres. Modern plastic erasers will remove errors without damage and can be sharpened to an edge with a knife for precise use if worn to a rounded profile.

Sharpening pencils

Taking great care, sharpen with a craft knife, paring away the wood with long strokes. Supporting the lead against a flat surface prevents snapping whilst sharpening to a final point. Pencil sharpeners make short points that blunt easily.

4 4B pencils blunt and smear easily, but are pleasantly soft and manageable if sharpened frequently.

5 As your soft high B grade graphite wears down with use, a sharp edge will develop, allowing fine lines to be drawn.

6 Traditional coloured pencils offer alternatives to black, but are not as easily erased completely. Mix colours by cross-hatching.

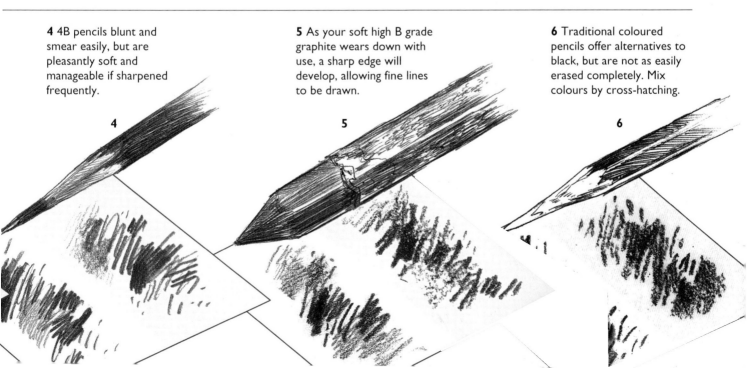

MARKERS

Types of marker

Many water-soluble markers are playthings and fade rapidly, while others are moderately durable. Some spirit ink pens are similarly not light-fast enough to allow work to be hung in daylight. However, they are suitable for work destined for print reproduction.

Types of tip and nib

Water-based markers often have tapered tips and will make broader marks if used at a shallow angle. Some water-soluble ink sets when dry. Other types can be diluted with water to spread it thinly over the surface. Spirit markers may have round, chisel or wedge-shaped tips, and require some care to find the right angle to make the mark you want. Markers with round nibs make constant marks of fixed widths. Markers manufactured for calligraphy have precise chisel-shaped tips and may contain light-fast ink.

Paper surfaces

Photocopying paper is non-yellowing and good for small roughs and experimenting. Layout pads offer larger sheets of smooth paper for full-scale trials and final versions. Hot-pressed papers or acid-free smooth cartridge are suitable for work meant to last. Spirit inks will work on many surfaces but easily scratch off shiny ones.

Drawing effects

Extra-fine tips are useful for delicate additions, stippling (making small dots) to create texture, or establishing a light preliminary framework for a complex drawing.

Fine tips are used for making preliminary marks, for detail work and for hatching delicate tones with criss-cross lines. They also allow you to create finer textures in large drawings.

Medium tips are used for making bold corrections and hatching strong tones. They can also be used for adding emphasis to small fine-line drawings and strengthening fine lines in large drawings.

Broad tips are the last resort for corrections, allowing you to add weight to rectify errors. They are also used in big subjects for blocking in areas of solid dark tone, and making strong lines and bold, textured hatching.

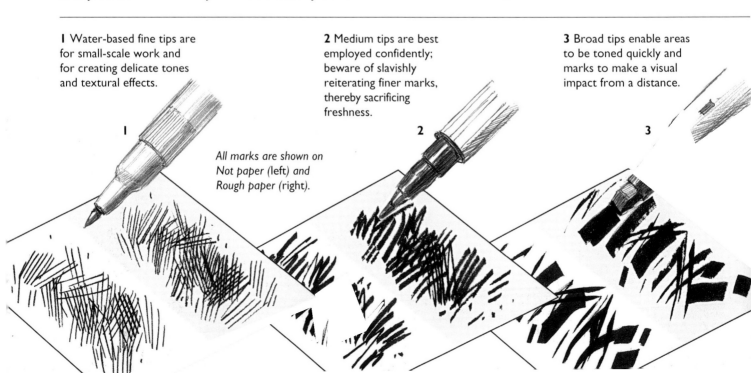

1 Water-based fine tips are for small-scale work and for creating delicate tones and textural effects.

2 Medium tips are best employed confidently; beware of slavishly reiterating finer marks, thereby sacrificing freshness.

3 Broad tips enable areas to be toned quickly and marks to make a visual impact from a distance.

All marks are shown on Not paper (left) and Rough paper (right).

Corrections

Water-based markers: Some water-based markers are waterproof when dry, others remain soluble. Where soluble water-based markers have been used, partial removal by light sponging can be attempted first. When dry, whiting out can disguise any remaining unwanted effects.

Spirit-based markers: Invisible corrections are virtually unobtainable if spirit inks are misplaced but in the event of disaster, softeners may help to reduce the strength of the unwanted lines. Solvents contained in marker pen-type dispensers are intended as blenders to merge marker tones together. Sprays allow more pigment to be dissolved and contain a product designed to allow wiping off, but even so will invariably leave traces. If the reduced tone is still too strong, whiting out will conceal the remainder.

Using washes over markers

If you intend to apply a wash over either water- or spirit-based marker ink, ensure your paper has been stretched. This process involves placing your paper on a plywood or wooden surface, damping the paper lightly and evenly with a wet sponge and then quickly securing it all round, covering the margin of paper and board with damped brown-gummed tape. Watercolours come in tube (*above left*) or pan (*above right*) form.

Water-based inks
Many water-based inks become re-soluble when a wash is applied over them. You can put this volatility to good use in your work. If, however, this 'bleed' effect is unintentional, it can be corrected (see Corrections, above right).

Spirit inks
Spirit inks are set when dry and stable under water-colours, so use washes to create tonal variations if these are required. Colour density can be built with overlaid washes, allowing each layer to dry before applying a fresh layer of wash.

Opaque liquid acrylic paint
Unwanted water-based effects are best disguised using opaque liquid acrylic paint, which is least likely to be visible by a scanner if the work is to be printed out for reproduction. The corrected patch will receive over-drawing differently.

Spray solvent
Spray solvent will facilitate the softening of unwanted spirit ink marks before allowing you to white out with opaque white liquid acrylic or gouache. In some instances, softening with solvent can be used as an intentional effect.

4 The widths of fine spirit-based tips vary – depending on the manufacturer – from fine to almost medium sized.

5 Spirit-based medium tips dispense ink at a steady rate; used quickly they may produce broken linear textures.

6 A broad spirit tip gives a dense tonality and is appropriate if you want to achieve richness in a piece of work.

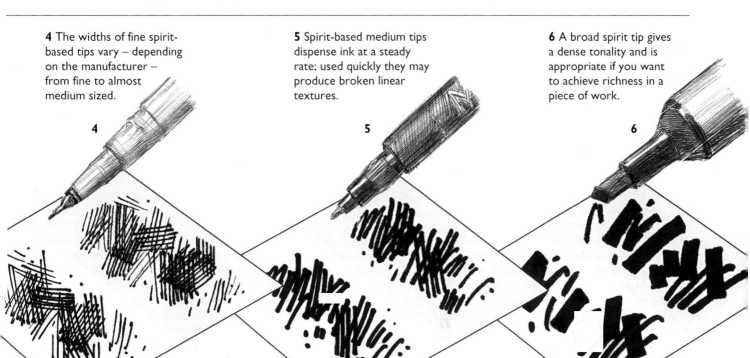

PEN AND INK

Types of pen

Dip pens are fitted with cut steel drawing nibs with a long profile. Reservoirs, designed to retain ink in the hollow of nibs, will extend drawing time between dipping. Reed and bamboo pens and other natural nibs – such as quills cut from goose feathers – also give flexible and responsive marks. Technical pens, roller balls and markers are designed to make constant marks; inventive mark making is required to compensate for their lack of variety. Brush pens (not illustrated), another type of marker with a long tip, make variable marks but, like many markers, contain impermanent inks and fade fast.

Using pen and ink

Pen work cannot be erased easily. Some corrections are possible (see right) but all are obtrusive, so pen drawing calls for a tentative approach. By using diluted ink or broken lines, a drawing can be done faintly first. Alterations can then be made by continuous lines of greater thickness or tonal strength.

Paper surfaces

A rough surface texture will deflect fine nibs. Choose smooth or hot-pressed watercolour paper or cartridge with a firm surface, as the nib may bleed into the fibres of softer surfaces.

Ink density

Weak ink dilutions are recommended for making an initial statement in your drawing. Waterproof inks contain a varnish that curdles when diluted with tap water; always use distilled.

Beautiful medium tones can be obtained from varying the dilution of non-waterproof inks, such as calligraphy or Chinese drawing ink. Test for strength on scrap paper.

Strong ink solutions are useful for creating subtle variations in tonal depth, or for overriding weak dilutions when correcting. Label any stored surplus to distinguish it from full-strength ink.

Tonal density can be built up by multiple linear cross-hatching with a pen nib, or over-laying weak wash dilutions when drawing with a brush. Pen lines are easier to add with confidence to a drawing already defined by washes.

1 Drawing nibs for dip pens are slightly flexible, with more pressure allowing a broader stroke.

2 Every side of a reed nib will draw; the mark depends on which is used.

3 Bamboo pens are robust and make even bigger marks when used at a shallow angle.

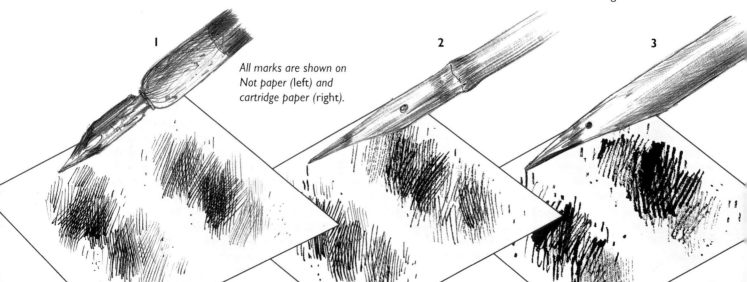

All marks are shown on Not paper (left) and cartridge paper (right).

Inks

Most coloured inks will fade, but liquid acrylics are more permanent, as are some black inks. Stick ink (shown behind the ink bottle, *above*) must be ground wet in a stone dish.

Quill pens

Use a sharp blade to cut quill pens (*top*), preferably from goose feathers, and a hot wire to burn a hole near the tip for ink release. Sharpened stick pens are used as dip pens but may need reservoirs, contrived by tying a flat sponge around the stick, then loosely wrapping it with waterproof material. Load the ink by brush and release it by squeezing.

Quill pen marks (*above*) are variable from delicate to robust. The quill's durable yet flexible tip allows great definition and precision.

Stick pens (marks shown *above*) allow work on any scale; long sticks give an extended reach that is useful for large-scale drawings.

Corrections

It is impossible to disguise an error completely in an ink drawing, but the correction is better than an obvious mistake. If you make a mess, try whiting out with gouache or liquid acrylics, or cutting in a patch stuck from behind with conservation tape or glued on, or, as a last resort, scratching out gently with a sharp blade.

Whiting out

Gouache leaves a deposit on the paper surface that enables drawing over the correction. Liquid acrylics, while impermeable, affect ink absorption.

Cutting in

Place paper behind your error, then cut carefully through both sheets with a sharp blade to create a matching insert and secure with tape from behind.

Patching over

Sticking in a patch of matching paper is obtrusive in small drawings, but effective on a larger scale.

Scratching out

Scratching out errors with the tip or scraping with the side of a sharp blade abrades the paper. An abraded surface will always break up further lines.

4 Modern technical pens, whether refillable or disposable, combine marks of a uniform width with convenience.

5 Many handy writing pens, including gel writers and roller balls, may contain impermanent inks.

6 For drawing, technical pens with dual-prong nibs can be filled with coloured washes by filling the reservoir between the prongs with a soft brush.

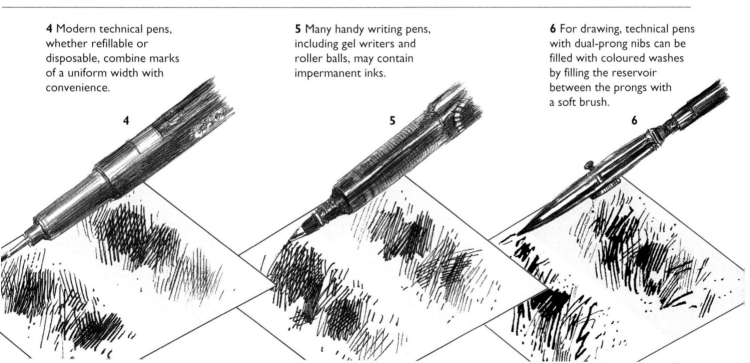

PHOTOCOPIERS

If, like me, you began drawing your own comic strips after copying the strips and characters you found in commercial magazines, you may also have spent a great deal of time trying to fit detailed drawings into very small spaces. I was drawing strips for quite a while before I realized that comic art is not usually drawn at the same size as it appears on the printed page. In most cases the pages are drawn much bigger and are then reduced to fit the format of the comic book in which they are appearing. This knowledge gives you the freedom to draw your comics at a size you are comfortable with. There is an added bonus, too; when your drawings are reduced in size, any mistakes and imperfections will also be correspondingly smaller and far less noticeable, as you will see from the examples shown here.

Beware, though, that you don't take this freedom to extremes and put so many tiny details into your work that they disappear when reduced. A good way of checking the effect reduction has on your drawing is to use a photocopier as you work – when you've got a finished page of artwork, use the photocopier to reproduce it in several different sizes, and then compare the results.

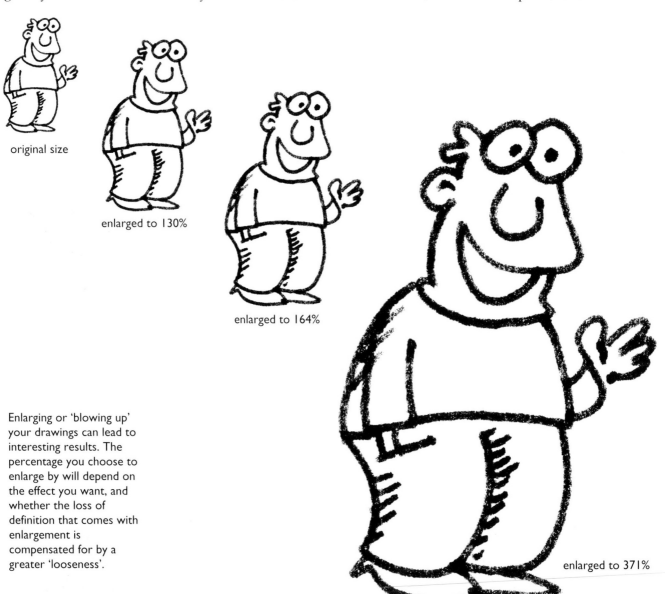

original size

enlarged to 130%

enlarged to 164%

enlarged to 371%

Enlarging or 'blowing up' your drawings can lead to interesting results. The percentage you choose to enlarge by will depend on the effect you want, and whether the loss of definition that comes with enlargement is compensated for by a greater 'looseness'.

COMPUTERS

Computers are increasingly being used in comic art. There are programmes, for example, which allow you to manipulate your original image. Images A–E (*right*) show some of the effects that can be achieved using such a programme.
In order to manipulate your image, you will first need a scanner which enables you to scan in your image to create a computer file. This can then be opened in your chosen image manipulation programme. If you are particularly adept with a computer you could consider assembling whole pages of comic strips, or even entire comics.

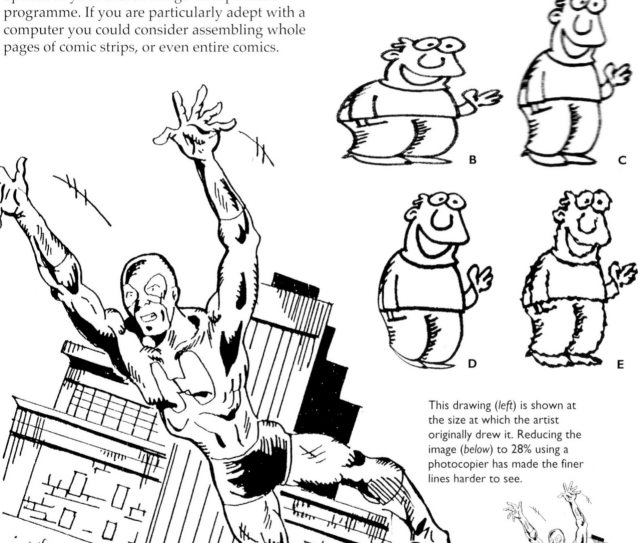

I scanned in the 'little man' shown on page 12 and then manipulated him. Here's what I did:
A squeezed vertically by 50%
B squeezed horizontally by 50%
C 'blur' effect
D 'spherize' effect
E 'ripple' effect

This drawing (*left*) is shown at the size at which the artist originally drew it. Reducing the image (*below*) to 28% using a photocopier has made the finer lines harder to see.

Basic Shapes

There are so many exciting and hilarious stories to be told in comic strips, it's easy to forget that each and every drawing starts off with some very simple basic shapes. The whole drawing process becomes a lot simpler if you get these basic shapes right. Do remember, though, that just because the shapes look simple doesn't mean you shouldn't practise them until they become second nature – after all, these are the basics on which you're going to build your entire comic strip story, and perhaps even your whole comic art career. Investing a little extra time in getting them right now is bound to pay rich dividends later.

Believe it or not, you don't need super powers to be a super comic artist. If you can draw simple matchstick figures, basic shapes and

'sausages' like these (*above*), you can master everything presented in this book, and a great deal more besides!

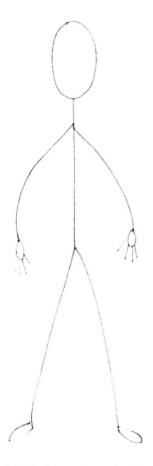

Here's the usual matchstick figure that almost everyone can draw. All we're going to do in the next few drawings is refine it a little.

Let's base the figure a bit more on the human skeleton. Add an oval to the upper body for a 'ribcage'. (Draw these first stages in pencil – you can add ink later.)

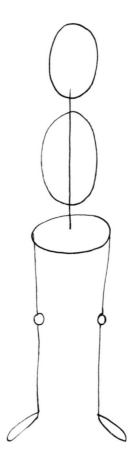

Now let's add an oval for the hip bone and join the legs to it.

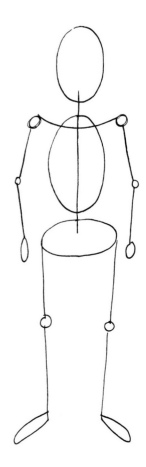

Arms and a 'collar bone' complete our basic figure. Try to get a sense of everything hanging from this frame, just as you would with a real skeleton.

Once you've learned to draw your basic figure, how simple or detailed you want to make your finished drawing is entirely up to you. There are some artists whose finished figures may not look all that different from their rough versions (this is particularly common in the field of humorous comics), while others enjoy adding details to make even the most fantastic images as realistic as possible. As you begin building your own figures from scratch, take a close look at the work of your favourite illustrators and try to identify the basic shapes their drawings are built on. The chances are they will be very similar to ones you're learning to draw here.

Artist's Tip

Develop your own 'X-ray vision'. As you look at figures in comic books, on TV or in real life, try to 'see' the basic figure shape underneath. Once you've got the knack, you'll find that building a drawing on top is easy.

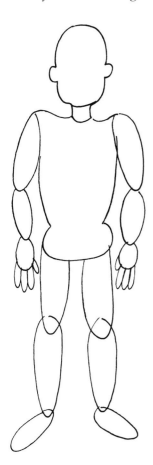

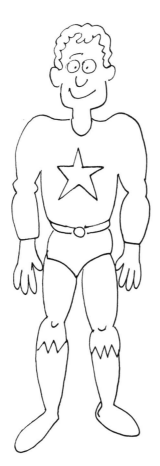

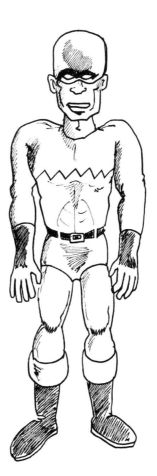

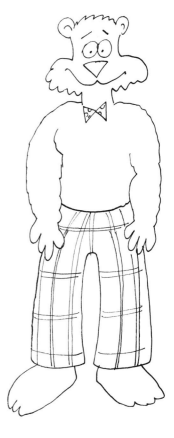

Now we're ready to flesh out the skeleton with simple ovals and sausage shapes drawn on top.

Lastly, add details in ink to create your cartoon character. You can rub out the pencil lines you don't need later.

Practise this basic figure and you can make it as 'cartoony' or realistic as you want to ...

... you can even bring non-human characters to life.

Proportion

Getting to know the rules of proportion – that is, the size different parts of the body should be in relation to one another – is a very important task for any artist, whatever type of painting or drawing he or she is doing. There are two reasons for this. First, even though many of the worlds created in comic strips are pure fantasy, they need to be believable and have their own sense of reality. Getting the proportions correct can make all the difference between a character looking 'right' or plain wrong. The second reason for spending time learning to get the proportions in your comics spot on is the creative freedom this allows. When you know

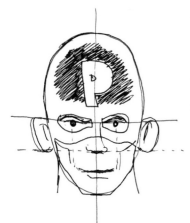

The rules of proportion apply to the head too (*left*). Note how I started by dividing the head shape into four quarters and, most importantly, that all the features are in the lower half of the head.

When you know that the ears always fall between the line of the eyebrows and the tip of the nose, or that the edges of the mouth are always directly below the centre of the eyes, drawing realistic faces – even super-hero ones – becomes much simpler.

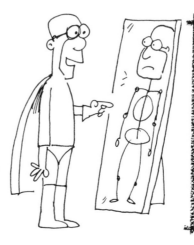

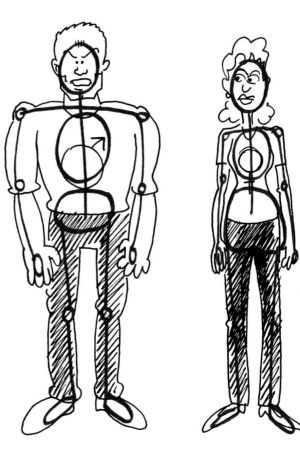

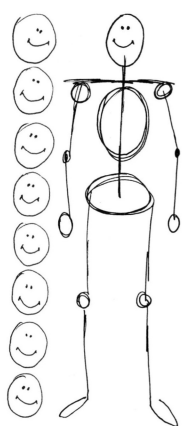

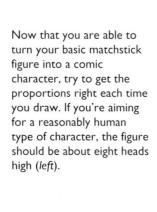

Now that you are able to turn your basic matchstick figure into a comic character, try to get the proportions right each time you draw. If you're aiming for a reasonably human type of character, the figure should be about eight heads high (*left*).

There are slight differences in the make-up of the male and female frame. For instance, the male usually has broader shoulders, whereas the female has wider hips. Adapting your basic figures accordingly will help you draw both sexes properly (*right*).

Artist's Tip

Spending time observing will help you to get the proportions of your comic figures right. Start with yourself. Stand in front of a full-length mirror and assess. Are you long or short in the body, arms or legs? Describe yourself in terms of simple shapes.

how to get proportions right, you'll also know how to get them wrong deliberately in order to make your work more exciting.

The 'larger than life' characters that arise out of this approach are always popular with comics fans. Exaggerating the proportions of the whole figure, or just one or two body parts, can immediately make your figures look stronger, more powerful or just plain hilarious. But, remember, you will only achieve this by making your drawings realistic in the first place.

The younger a child is the bigger its head in proportion to its body. If you don't take this into account in your drawings, your child characters may well end up looking like small adults.

The only unbreakable rule in Cartoonland is that rules are made to be broken. Neither Cheeseburgerman nor his mousy companion conforms to the eight heads high rule, but the drawings work anyway.

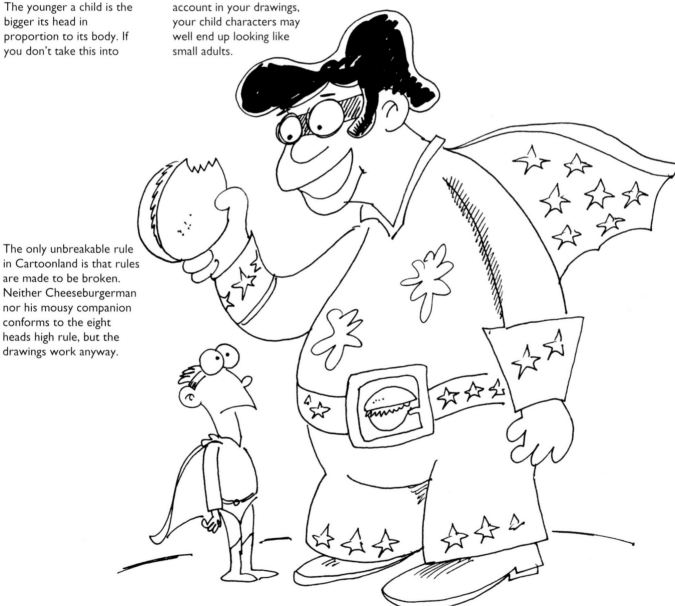

Body Movement and Gestures

Two elements which separate comic strip art from single panel cartoons are movement and gesture. Certainly you can show characters in individual cartoons participating in all manner of activities, but the whole idea of comic strips is to create the illusion that the characters are moving and coming to life as our eyes move from panel to panel. The illustrator has both to create the illusion of movement and also keep the characters looking the same as they move from panel to panel and pose to pose.

By now it should be obvious that even if you can draw figures 'out of your head', you need to take the time to build them from basic shapes. The shapes will always remain the same no matter what poses your figures are drawn in. It follows, too, that figures based on these shapes will also be much easier to keep recognizable.

Just as the most complicated figures can be broken down into their basic shapes, so the essence of each movement and pose can be captured in a line or two. If you can pin down the sense of a movement in a simple 'gesture drawing' – a quick sketch is sufficient – the sense of movement will remain, no matter how detailed your final artwork.

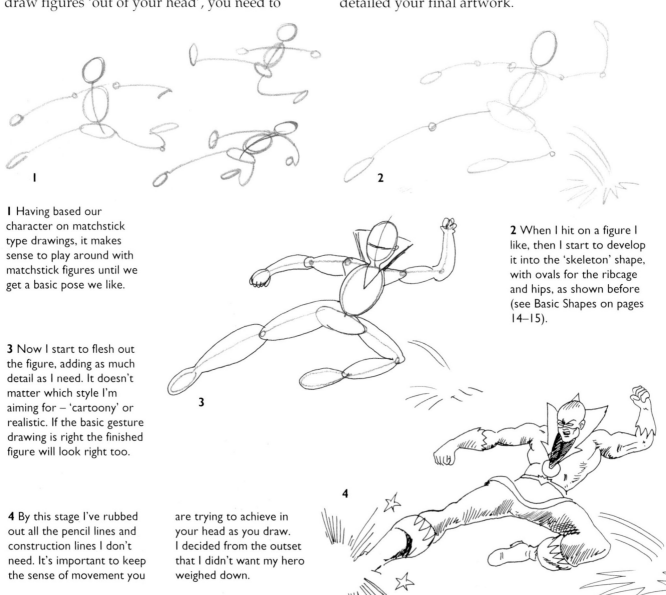

1 Having based our character on matchstick type drawings, it makes sense to play around with matchstick figures until we get a basic pose we like.

2 When I hit on a figure I like, then I start to develop it into the 'skeleton' shape, with ovals for the ribcage and hips, as shown before (see Basic Shapes on pages 14–15).

3 Now I start to flesh out the figure, adding as much detail as I need. It doesn't matter which style I'm aiming for – 'cartoony' or realistic. If the basic gesture drawing is right the finished figure will look right too.

4 By this stage I've rubbed out all the pencil lines and construction lines I don't need. It's important to keep the sense of movement you are trying to achieve in your head as you draw. I decided from the outset that I didn't want my hero weighed down.

Take action

It's often said that most comic strip artists and writers are secretly performers at heart. If you really want to get realistic movement into your drawings, it's time to stop hiding this side of your personality. One of the best ways to work out how to draw a particular movement or gesture is to actually act it out for yourself, or persuade someone else to do it for you. You can then use the 'matchstick people' shown here to capture the spirit of the movement. This will give you a frame onto which you can then build your finished drawing. Fear not, no one need ever know that the soaring super hero or marauding barbarian in your finished strip is actually you leaping around your bedroom!

Good gesture drawing isn't just important from a technical point of view, either. As we've already seen, comic strip art isn't solely about producing good drawings – it's about telling stories, and gestures play just as important a part in bringing your characters to life and describing how they are feeling as their expressions and what they say. Try to become a keen observer of how real people walk, talk and move and you'll find many useful gestures that you can use in your comic strip world.

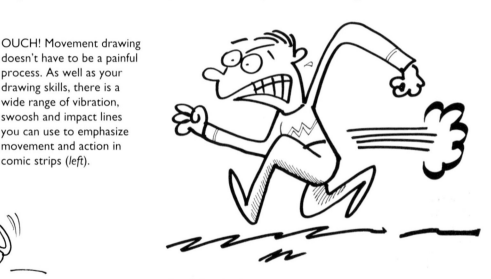

OUCH! Movement drawing doesn't have to be a painful process. As well as your drawing skills, there is a wide range of vibration, swoosh and impact lines you can use to emphasize movement and action in comic strips (*left*).

Don't be afraid to accentuate movement. Our characters don't just run, they run as if their lives depend on it (*above*).

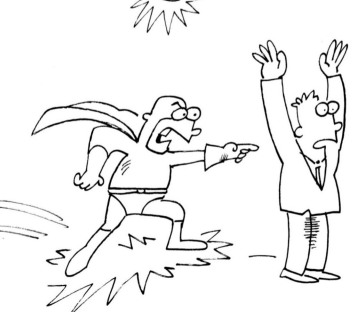

As well as getting your characters from place to place, movement and gesture can be important storytelling elements in themselves. Can you suggest what these characters (*left*) might be saying just from the gestures they are making?

Character Development

Most of us begin our comic drawing by copying our favourite characters from comics or TV. Some artists frown on copying, but I've always felt that, as long as you're not passing someone else's work off as your own, it's a very good way of studying the skills and methods employed by professional artists. Copying, though, can't compare to the fun and satisfaction of creating your own comics, and sooner or later you're bound to get the itch to do this.

Here's a pretty standard comic strip character. Let's see if we can make him more interesting.

An eye-patch or an obvious scar could hint at a mysterious past.

When choosing the look of your characters remember that you are going to have to draw them repeatedly from every angle. Distinctive clothes or physical features help to establish a character.

To plot the position of the main features and maintain the proportion of your character in profile, draw guide rules across from your 'face on' drawing (*above*), repeating for other angles.

Making the character less than perfect – by giving him bad teeth, for instance – can add a more realistic dimension to your stories.

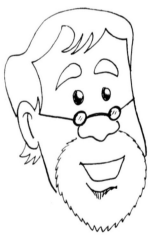

The addition of a beard and glasses make our character look a great deal more intellectual and learned.

Try every possible variation for your character – sometimes crazy ones like the one shown lead to interesting story ideas.

Choosing a character

We've already noted how every comic drawing begins with a simple, basic shape. It is at this point you should start building your character design. Now, as you begin drawing start asking yourself questions. What kind of story do you want to tell? Is your character going to be realistic or larger than life? Are you going to give him or her some personality or character flaw that might affect the way they look? Remember that designing comic characters is a bit of a juggling act – on the one hand you want to make them look different and individual, but it's also a good idea to make sure that the finished character is one that will be relatively easy to draw in different positions and poses.

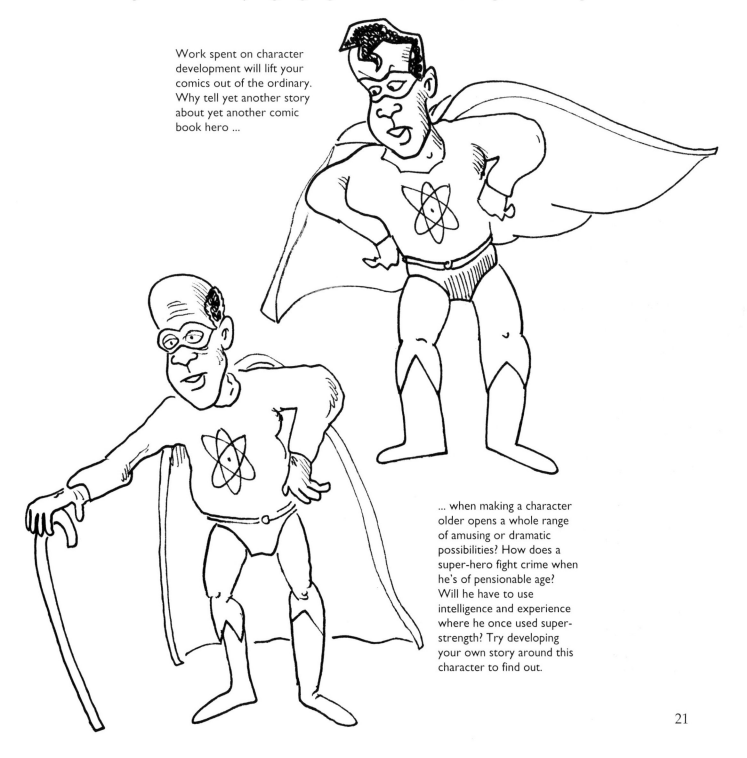

Work spent on character development will lift your comics out of the ordinary. Why tell yet another story about yet another comic book hero ...

... when making a character older opens a whole range of amusing or dramatic possibilities? How does a super-hero fight crime when he's of pensionable age? Will he have to use intelligence and experience where he once used super-strength? Try developing your own story around this character to find out.

Creating Your Own Characters

Super-heroes with amazing powers are, of course, a standard ingredient of many comic books. The only problem when it comes to creating new ones is that over the years it seems that virtually every variation on the theme has been explored! Don't worry – it's not just the basic idea of your character that will make it stand out. It's how you bring your individual drawing style to bear on that idea. Don't worry either if you don't get your character's 'look' right at the first attempt. If possible, take a look at some early editions of comics featuring world famous characters. Compare the initial drawings of these figures with those in the latest issues on sale today and you'll see that even the most recognizable characters have changed subtly in appearance through the years. Like any fine wine, a good character needs time to develop.

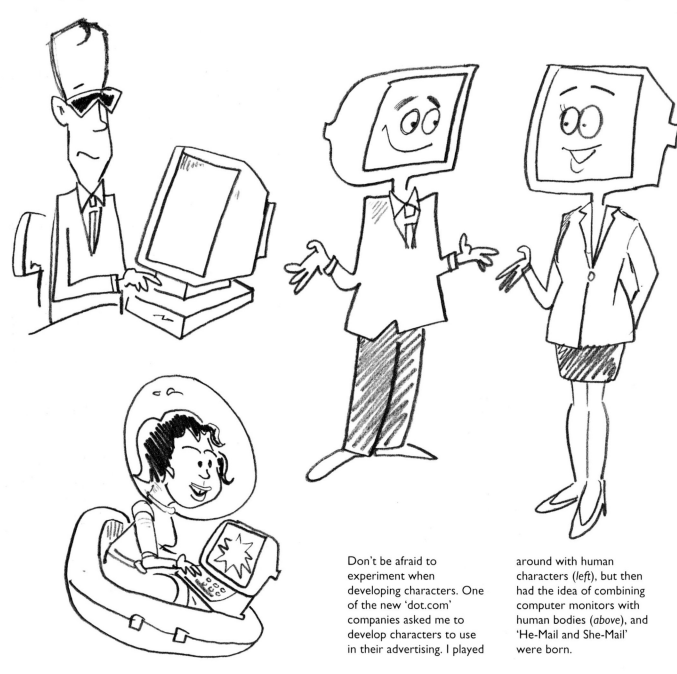

Don't be afraid to experiment when developing characters. One of the new 'dot.com' companies asked me to develop characters to use in their advertising. I played around with human characters (*left*), but then had the idea of combining computer monitors with human bodies (*above*), and 'He-Mail and She-Mail' were born.

Be ambitious

Perhaps one day a character of yours will be just as famous as one of the big comic stars. For this to happen you'll need to play around with lots of ideas until you get a character who fascinates and excites you. It is very important that you should feel this strongly. After all, the two of you may have to live together for many years to come.

To develop a character with the strength of a gorilla, I went back to basics, or rather to the zoo, where I did this quick sketch of a gorilla to give me ideas (*above*).

It's not just the size of the gorilla that's distinctive – the stance is, too. I adapted my basic gesture drawing accordingly (*left*) ...

Artist's Tip

Don't simply copy existing comic characters. Use them to inspire you to create distinctive characters of your own.

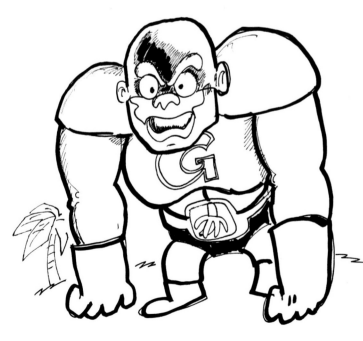

... and it was then easy to build my character on top. As you can see (*left*), wrong-doing drives him bananas.

Expression

I like to think of the characters in my comic strips as actors, and the more emotion they can convey the more exciting, funny or moving my comic strip stories will be. Yes, of course we use words in our comic strips too, and later on we'll be looking at how speech balloons and lettering can help tell the story, but comics are still primarily a visual medium and space for letters is always limited, so the more you can convey emotions through the actual character drawing the better.

Just as a good comic artist uses their own body as a model for movement and character poses, the best reference material for your character's expressions is your own expressions. Use a small

mirror to help you capture them. Don't be afraid to experiment with expressions, by pulling faces. The comic artist routinely uses these methods.

That 'larger than life' aspect also applies to the expressions of your characters. In real life there may not be much difference between, say, our expression when we're interested in something or when we're bored, unless we're at the extremes of these states. In comics, any uncertainty as to how characters are feeling will confuse the reader and take away from the illusion of reality. It's important – and much more fun! – to exaggerate expressions and leave no doubt about the feelings they are communicating.

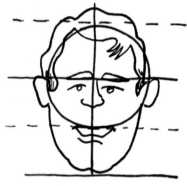

Before we learn to draw expressions, we have to master drawing heads (*above*). Luckily, just like the basic figure, the head can be broken down into simple parts. Start off with a circle and divide it into

four, then draw another line a half circle's distance below to mark the chin. We can now use this guideline to draw our face. Note that the eyebrows fall on the line that goes from the tips of the ears across, while the tip of the nose lands on the line that touches the bottom of each ear. If you were to draw a straight line down from the pupil of each eye, it should hit the corners of the mouth. Faces can be round, square, fat or thin, but these basic positioning rules apply whatever the shape of the face.

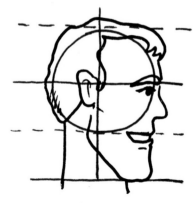

For the comic artist, keeping to the rules of proportion is particularly important, because once you establish your proportions you can turn the head left, right and in any position between while keeping your character looking the same.

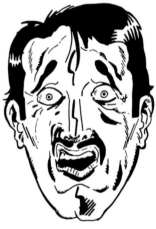

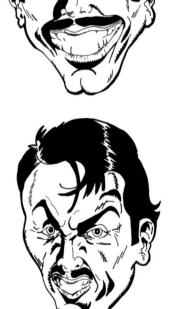

Happy, sad, angry, scared – these basic emotions are very easy to portray, as you can see from the above. The trick is to keep your character recognizable throughout a range of expression changes. Distinctive facial features, such as a moustache, help.

Humour comics allow you to go to town on creating larger than life characters. Here is 'surprise' taken to an extreme. Now see if you can surprise yourself by taking some of the expressions on these pages and exaggerating them. See how far you can go.

Comic panels often focus closely on individual details for dramatic effect. Once you've experimented with full-face expressions, try to convey equally strong feelings using one feature alone (*above*).

It's good drawing practice to try to convey emotions using expression alone. Comic artists have come up with a whole vocabulary of symbols to instantly communicate emotions and feelings, from greed to depression, from being in love (*above*) to being lovesick (*below left*). When looking through your collection of comics, keep your eyes open for such symbols. Learning them will help you in future work.

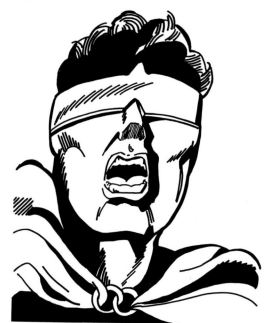

Next, try putting the 'message' across using only the bottom half of the face. Practise this technique so that you are able to convey emotion even when a character is masked or, as here (*above*), blindfolded.

In reality animals don't own the same rich expressive possibilities as humans. In comic strips they tell us as much as any human can.

'Human' Animals

While you can create an endless range of human 'actors' for your comic strips using the simple techniques in this book, your casting doesn't have to be limited to super-heroes, barbarians, football players and detectives. In the comic strip world talking mice, rabbits and big bad wolves are just as likely to pop up as these staple characters. In fact, some of the most famous and enduring characters in cartoons and comic strips are animals.

1 We start our animal drawings just the same as our human ones – with a basic figure in whatever pose we desire.

2 Once we have the basic figure, it's easy to develop the animal characteristics.

3 How much like a human or an animal you want your character to behave is entirely a matter of taste.

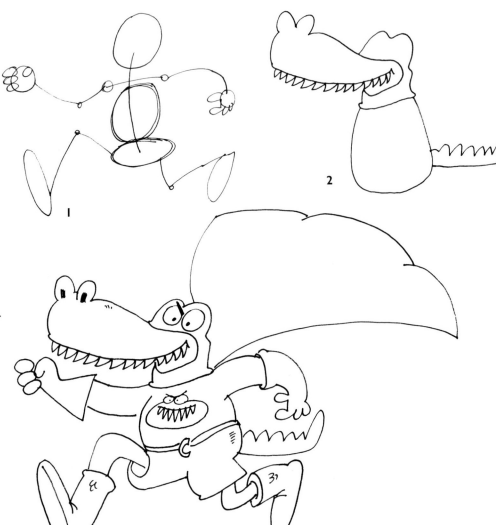

Once you've mastered human expressions, it really isn't very difficult to apply the same expressions to animal faces (*right*).

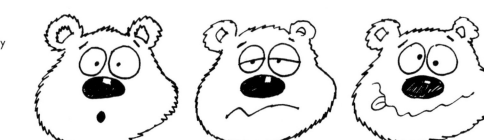

Anthropomorphism

The process of giving animals human characteristics is called anthropomorphism. Luckily, pronouncing the word is the hardest part. As you'll see from the pictures on this page, the same techniques you have been using to draw people can be adapted to the animal kingdom with very little extra effort. This process can also be extended to virtually any inanimate object. You can play around with them in the same way, bringing them to life and weaving comic strip stories round them.

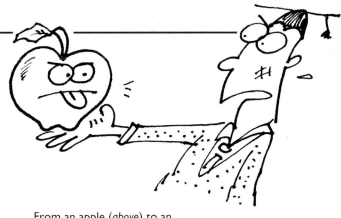

From an apple (*above*) to an entire building (*below*), no object is too big or small to benefit from a touch of anthropomorphism!

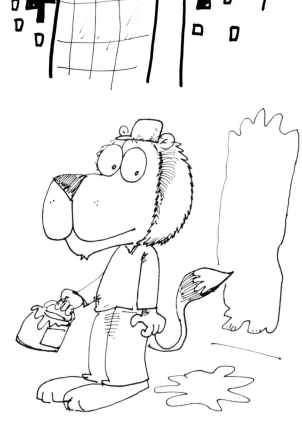

Story ideas can arise from putting several different animal characters to work on one task – for example, decorating – and seeing how anteaters, lions, octupuses or whatever creatures YOU pick would bring their individual talents to bear on the job.

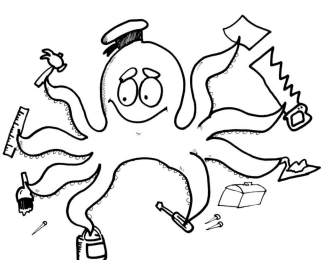

Clothing and Props

The great advantage of telling stories through comic strips rather than any other medium is that you can create as many different plots, locations, situations, even whole worlds, as you want, all with the same basic tools – your pen or pencil, some paper and, of course, your drawing ability. You will also need to develop sound techniques in the depiction of clothing and props. These can tell us almost as much about a character as his facial expression.

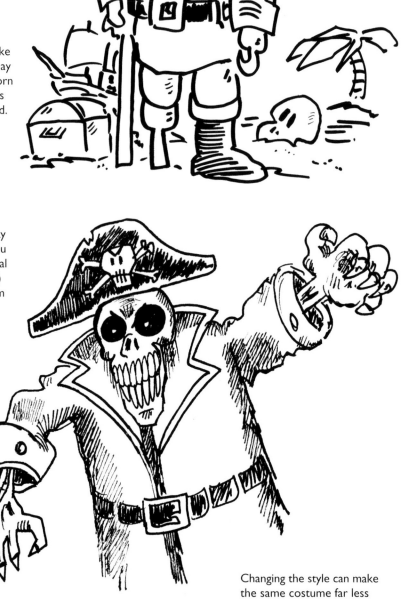

Comics and cartoons make use of costumes which may or may not have been worn by the real-life equivalents of the characters depicted. This drawing of a pirate (*right*), complete with props, is an example.

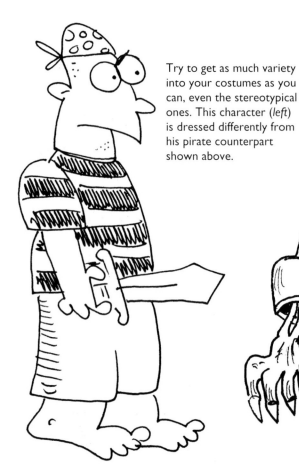

Try to get as much variety into your costumes as you can, even the stereotypical ones. This character (*left*) is dressed differently from his pirate counterpart shown above.

Changing the style can make the same costume far less humorous. Compare this with the image at the top.

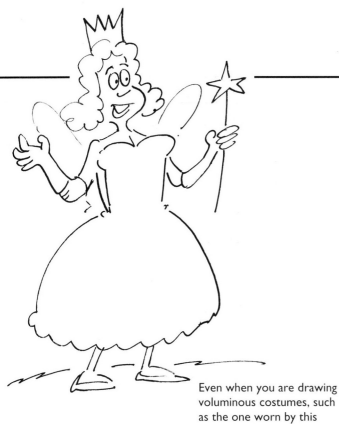

Dressing for the part

It would be impossible in a book like this to show you every possible uniform or prop that you can use in your comics, nor should it be necessary. You've probably guessed by now that almost every item – from a ballerina's costume to a space suit, and from a pencil sharpener to a fifty-storey tower block – can be drawn by building it up from its basic shape. Initially with shapes, always think simple, and then build.

Once you have put the basic shapes on paper, be on the lookout for small details you can add to each costume or prop to make your story more believable, but remember also that costumes and props are only there to help tell the story, they are not the story in themselves. As with every other component in your comic strip, don't be afraid to play around with your designs and make them a bit less realistic if it suits the story.

Even when you are drawing voluminous costumes, such as the one worn by this fairy (*above*), remember to build your drawing on the basic shapes we have been using all along.

Updating traditional costumes is fun and can generate story ideas. This modern-day tooth fairy (*left*) is ready for action, with electronic extractor and molar radar screen.

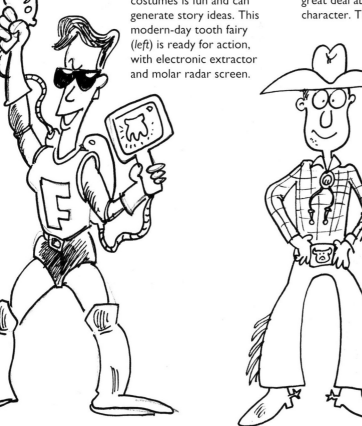

Costumes can tell us a great deal about a character. These two

different outfits (*below*) shape our ideas as to this character's musical tastes.

Other props

While it's obvious that clothing can tell us a lot about a character and can help make the character easily identifiable from panel to panel and from comic to comic, a particular prop can also become an important part of a character's persona. Think of the Lone Ranger, who always had his silver gun and bullets, or the Linus character in the 'Peanuts' strip, who drags his security blanket everywhere. (In the latter case the blanket wasn't just a prop, it told us a lot about the character's insecure personality.)

CYLINDER

Just as with your comic strip characters, you can create all the props you need with very simple shapes. Cylinders can be turned into gasometers, dustbins and robots. Cones can stop traffic, fly through space or be magically transformed into a witch's hat, while a simple box shape can be everything from a church to a fridge to the beginnings of a coffin.

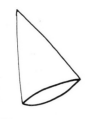

CONE

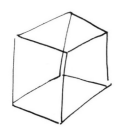

SQUARE

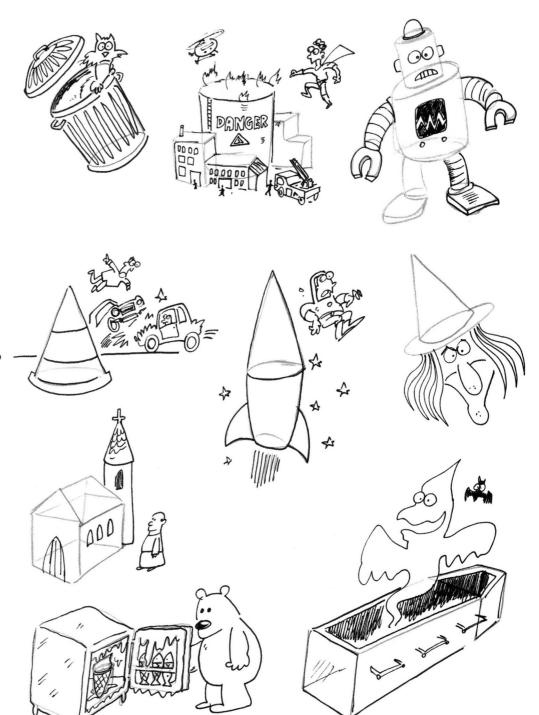

Themes and variations

Look out for small differences in the same kind of prop which can help set scenes or establish character. For instance, the telephone in an old mansion would probably be of a very different design to the kind in a slick record company executive's office. Be aware that just as fashions in clothing change, designs of products move with the times, too. Even if you are still using a mobile phone that's the size of a large shoe box, it doesn't mean your comic characters have to. Give your characters identities of their own.

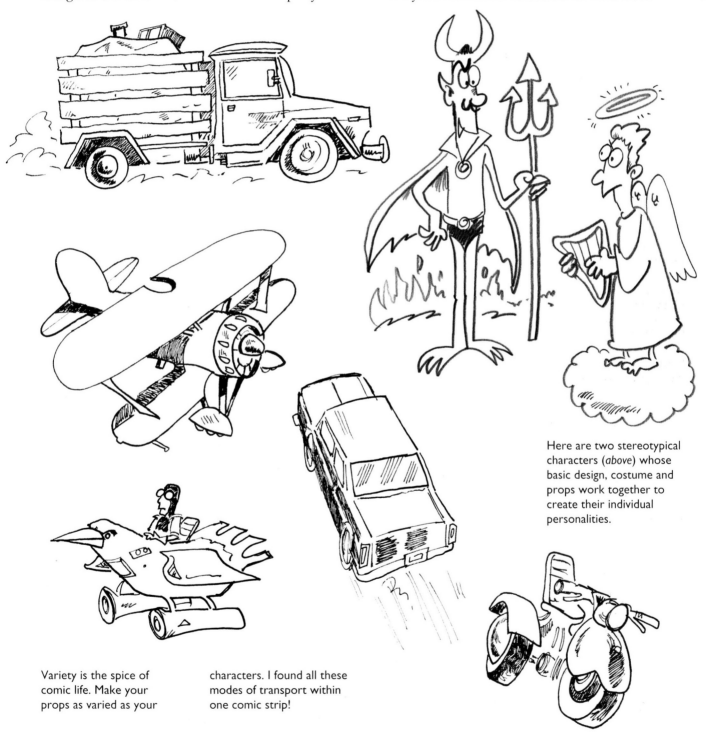

Here are two stereotypical characters (*above*) whose basic design, costume and props work together to create their individual personalities.

Variety is the spice of comic life. Make your props as varied as your characters. I found all these modes of transport within one comic strip!

Perspective and Foreshortening

If you want to bring your comic strip world fully to life, you'll have to create the illusion that it has depth and distance, just like in the real world. That's where the rules of perspective come into play. Very simply, perspective means that objects which are nearer to us will look larger, while those which are further away will look smaller. In comic strips characters, objects and backgrounds float around, so you'll need guidelines for keeping them in place.

As you can see from the pencil sketch (*below, top*), all lines in the picture vanish at a single point on the horizon line which is known as the 'vanishing point'. This is called 'single-point' perspective. If you construct the buildings using the same lines as guidance the illusion of depth is easy to achieve. If you want to show angles and corners you will need to use 'two-point' perspective (*bottom*). Once again the sketch on the right shows that the drawing is constructed on lines vanishing to two points on the horizon line, on either side of the scene.

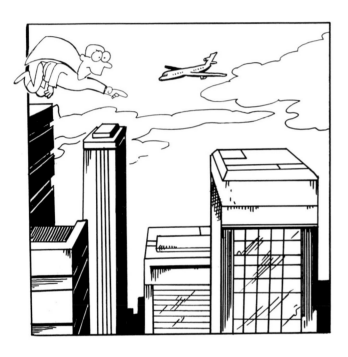

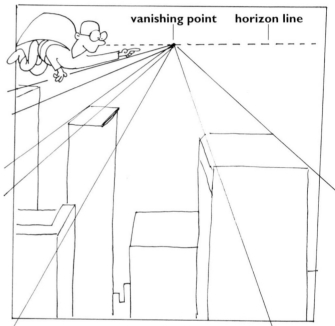

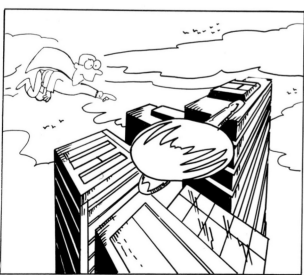

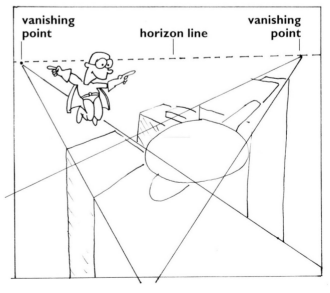

Vanishing points

The best way to achieve perspective in your work is to imagine that you are standing inside your drawing and think about where the horizon or eye-level line will be. That's the point at which objects in the distance seem to disappear and is referred to by artists as the 'vanishing point'. Once you have established where your vanishing point is, it's a relatively easy matter to rough in guidelines to ensure that everything in your drawing stays properly in perspective. In comics, of course, some pictures may have more than one vanishing point, but don't worry – the basic principle remains the same. In the pictures on these pages you'll see three different kinds of perspective which are routinely used in comics, with guidance on how to get the most from each of them. To add drama and excitement perspective can be exaggerated and distorted. This is a technique often used in comics.

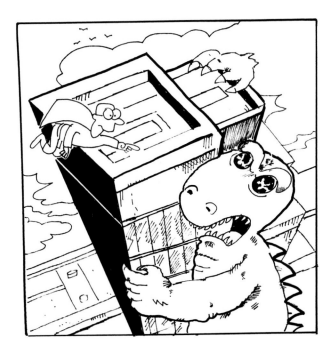

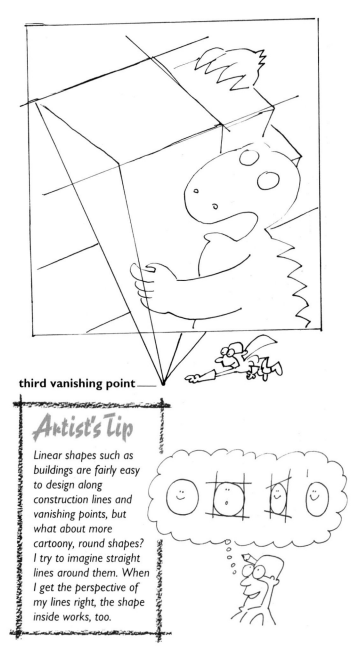

third vanishing point

Since the world of comics is larger than life, it is often necessary to show taller-than-tall buildings, extra-large monsters or simply to view the action from a highly dramatic angle. That's where 'three-point' perspective comes in handy. In addition to the two vanishing points we have used before there's a third vanishing point, which, as shown in this picture (*above*), is placed outside the picture frame. See if you can use the same technique to construct dramatic drops or dizzying heights in your strip.

Artist's Tip

Linear shapes such as buildings are fairly easy to design along construction lines and vanishing points, but what about more cartoony, round shapes? I try to imagine straight lines around them. When I get the perspective of my lines right, the shape inside works, too.

Perspective is important when it comes to making your comic strip world look more 'real'. But comic strips aren't real, and quite a lot of the techniques we use as comic artists are basically tricks to fool the eye and the mind into seeing drama, action and excitement in what are essentially flat, static drawings on a white sheet of paper. The 'larger than life' aspect of comics is one that I've stressed throughout. In order to achieve exciting effects, it's often important to exaggerate the techniques that are at our disposal. Now you have seen the benefits of perspective in practice, let's look at a very important technique associated with it.

Foreshortening

The term foreshortening is used to describe the fact that objects which are closer to us are drawn larger than objects which are further away. It follows that foreshortening also applies to parts of objects: if a super-hero swings his fist in our direction, the fist which is nearer to us will be drawn bigger then the rest of his arm. In comics, though, this simple rule is taken to extremes to produce dramatic effects. As you can see from the examples shown here, although the final effect may be exaggerated, it is achieved using the same basic, logical steps employed on more realistic drawings.

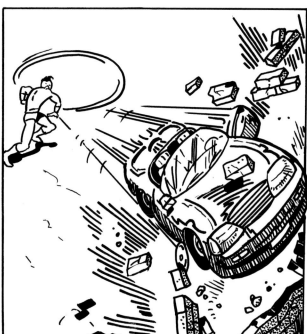

Now this is what I call road rage (*above*)! Subtle use of foreshortening helps make scenes like this one more believable ...

... unlike this blobby science fiction creature (*right*), whose limbs have grown alarmingly bigger.

Artist's Tip

It's best to experiment with perspective and foreshortening in rough before finally inking in your drawing. But, it's still easy to make a mess of one drawing and ruin the whole page. If this should happen, simply redraw the panel and carefully stick it over the original.

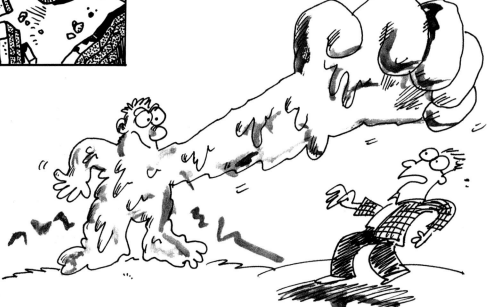

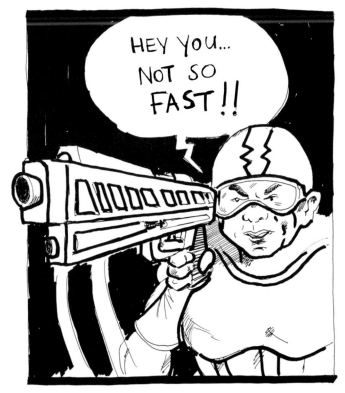

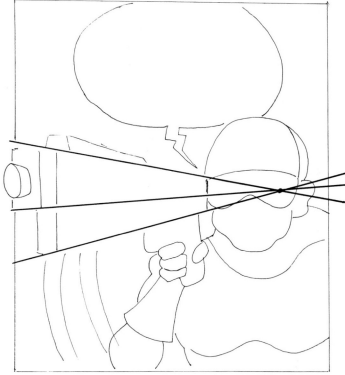

The classic 'looking down the barrel of a gun' shot uses foreshortening to good effect. Note here (*above*) that having the gun protrude from the panel enhances the effect. The pencil version (*above right*) shows how breaking the gun into simple geometric shapes makes the end result possible.

Experimenting with foreshortening will help you to judge what looks right. It's obvious that the exaggerated hands and feet of this hero (*right*) look bigger to emphasize that he's rushing towards us.

Backgrounds

Backgrounds in comics are a lot more than just locations in which your stories take place. The right background can add tremendously to the mood and feel of your story – it can even change the effect of your story altogether. Imagine a murder mystery where the climax is set in a spooky old mansion, and then consider the same plot being played out in a bouncy castle.

Study backgrounds and locations

Just as with clothing and props the trick with comic backgrounds is to make them an important part of the story without having them overpower either the characters or the plot. Once again it's important to study as many backgrounds and locations as possible, both in published comic books and in real life. This will help you identify the kind of telling details that will immediately set the scene and plant the location so firmly in the reader's mind that, later in the comic strip, you may be able to play up the important action and drop the background.

Less is often more. The establishing scene at the top of the strip opposite shows a cityscape. As we 'zoom in' through the strip, the background detail recedes. In the panel from later in the same story (*above*), we get another look at the location, but from a different angle, heightening the drama.

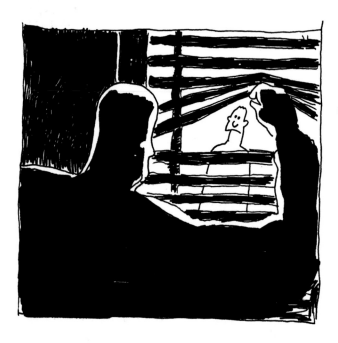

As well as the details of the scene, you can use shadow and lighting effects to add to the mood (*above*).

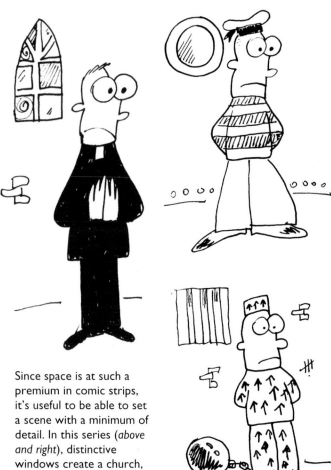

Since space is at such a premium in comic strips, it's useful to be able to set a scene with a minimum of detail. In this series (*above and right*), distinctive windows create a church, ship and prison scene.

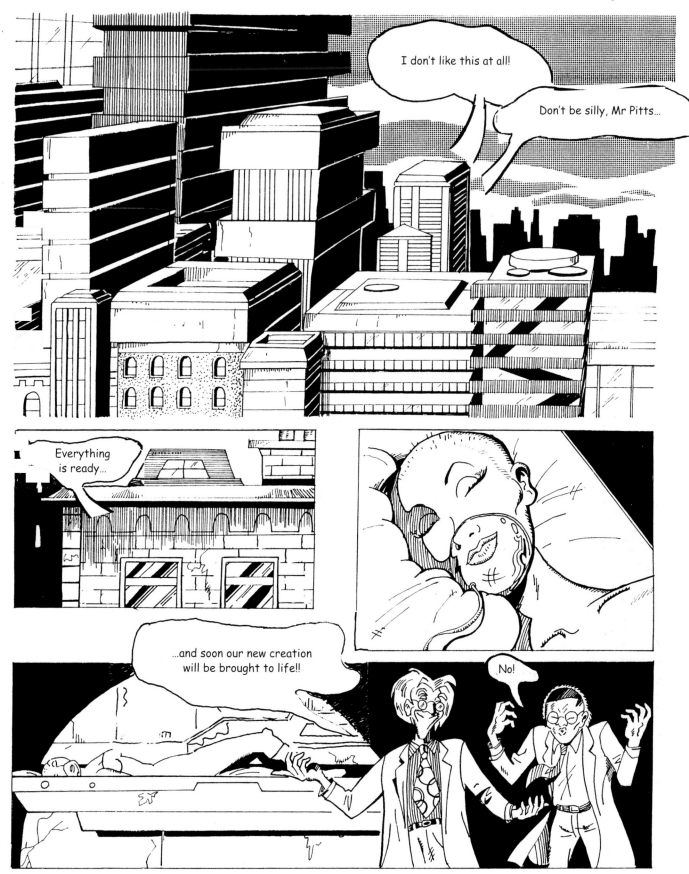

Speech Balloons

Although there have been some very successful comic strips created using pictures alone, it is in its ability to combine words and pictures that the comic strip really comes into its own. Most people associate 'speech bubbles' or 'speech balloons' with comics. In fact, artists have been using these devices to convey dialogue for a very long time, certainly since the days of the Bayeux Tapestry, and back even further into Ancient Egyptian times. Speech balloons have become an important – and expanding – part of the comic artist's tool box. A whole range of different balloons has been developed and is available for you to use to convey feelings and

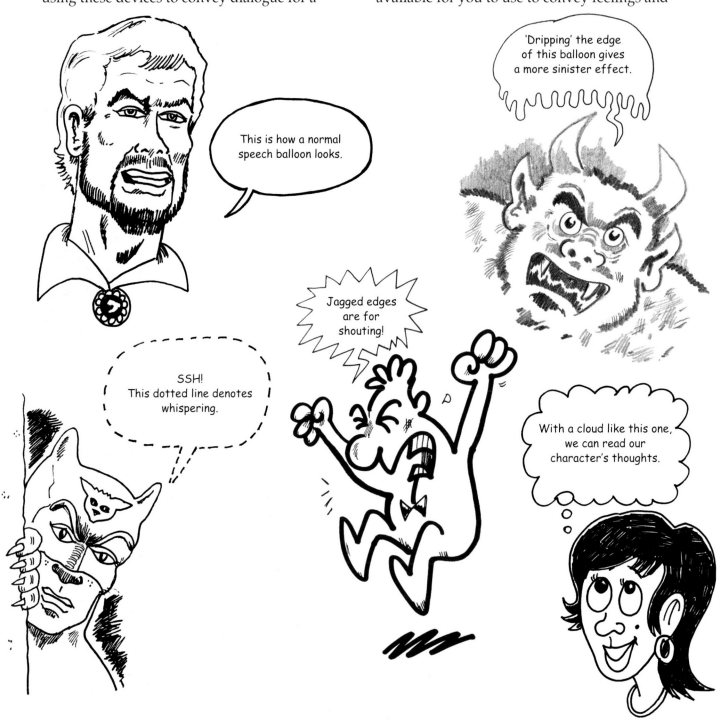

This is how a normal speech balloon looks.

'Dripping' the edge of this balloon gives a more sinister effect.

SSH! This dotted line denotes whispering.

Jagged edges are for shouting!

With a cloud like this one, we can read our character's thoughts.

emotions. In many cases the design of the balloon tells us how a character is feeling, even before we get round to reading the words. On these pages I have shown some of the most common types of speech balloon, but you will come across many others. When you see a new balloon device that you like, consider its effect and then try using it in your own work. Don't be afraid to attempt creating new balloon designs of your own, either. After all, comic strips are a living artform and you are just as entitled as anyone else to have your say as to how the artform should develop, through every aspect of your work, including speech balloons.

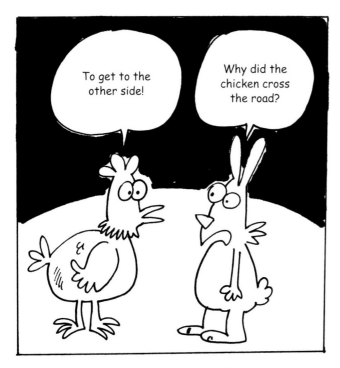

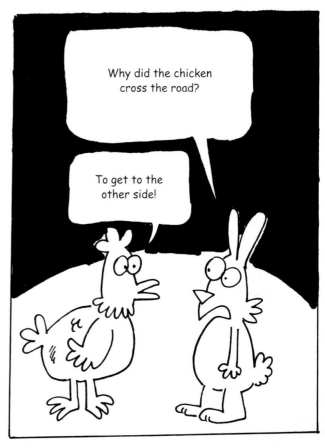

This is one of the most common mistakes rookie comic artists make with speech balloons (above) – confusing the sequence of speech. Always put the formation you want read first on the left, unless you have room for this sneaky trick (right).

Lettering and Type

Comic strip lettering isn't just confined to speech balloons. In comic strips we try to portray every aspect of our imaginary worlds visually, and that goes for all the Whams! Pows! Crashes! and Bangs! that occur there, too. When lettering your comic strip, you should strive to be every bit as creative as you are when you are drawing the pictures. Once again, these pages show just a small fraction of the different lettering effects and types available to help you tell your story more effectively.

It goes without saying that an exciting or innovative lettering effect is not always the most suitable for conveying meaning. Your lettering won't work – and you won't have achieved what should be your main aim – unless the reader can actually see what the word is. Spending time on basic planning and preparation in this area will give you the freedom to be creative.

You can build your letters in the same way as you draw your figures. Start off with basic shapes in pencil (1). Then firm and straighten up the edges (2). You can add extra effects, such as flashes, to suit your story (3), or a 'drop shadow' to make your letters appear more three-dimensional (4).

Here are some sound effects where the design of the letters helps convey the sound (*left and below*).

Putting one letter slightly in front of the next helps map the direction of the ball.

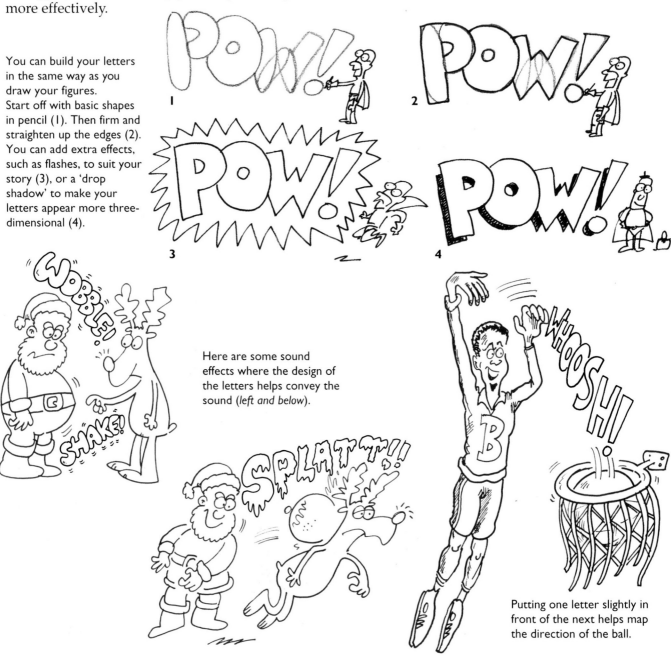

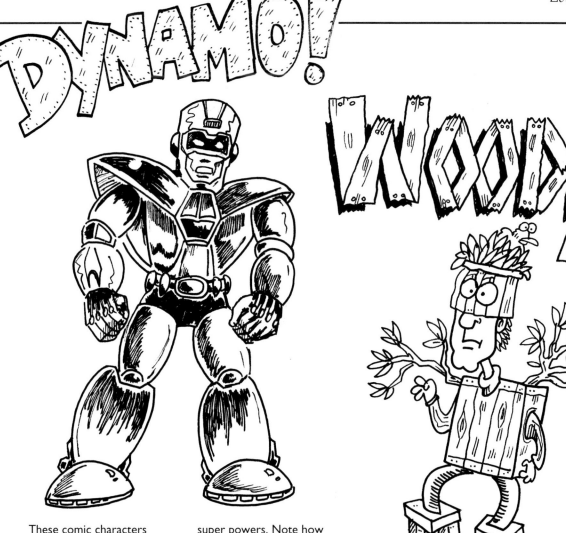

DYNAMO!

WOODEN MAN!

These comic characters (*above and right*) have logos which match their distinctive costumes and super powers. Note how wood and steel effects may be created simply by adding a few lines and dots.

With a little imagination sound-effects lettering can almost become part of the story, as in the horror effect here (*below*). If you try this, don't 'drip' the letters so much that they are unreadable.

HORROR STORY

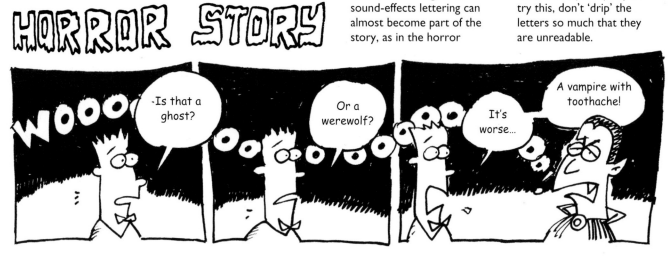

WOOOO

-Is that a ghost?

Or a werewolf?

It's worse...

A vampire with toothache!

Special Effects

Who can say how many comic strips have been drawn over the years and how many amazing adventures and fascinating tales told? The need to make each new comic story fresh, different and visually exciting means that artists have developed an amazing range of special effects to bring the two-dimensional world of the comic strip to life on the page.

In this section you'll come across some of the most common effects, but the more comics you study the more visual devices you'll add to your collection. From a planet exploding to a journey into the heart of an atom, no matter what visual challenge your story poses, you can be sure that some artists will have found a way to capture the effect in pen and ink.

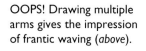

Tracing this figure several times gives the impression of great speed (*above*); the weight of the lines becomes lighter as the images recede.

OOPS! Drawing multiple arms gives the impression of frantic waving (*above*).

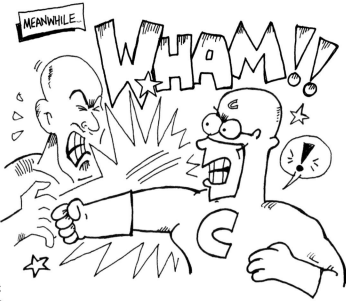

In comics it's not just the visual sense that's visual – here's how to show a particularly smelly piece of cheese.

Impact flashes don't just help emphasize punches, kicks and elbows. By masking any real violence, they let the reader's imagination do the work.

Going it alone

If there is an effect you want to portray and you can't find an existing visual device, you can always have a go at creating something of your own. Bear in mind that all of the 'standard' cartoon symbols – from speech balloons to lightbulbs over the head – had to be created by someone, somewhere. If you are wanting to convey a new effect, you may have to try several different versions before you find one that works. Try your ideas out on potential readers, but bear in mind that what you say when you test your work has a big impact on the usefulness of the answers you get. The question "Does this picture show that the person is dizzy?" will usually get a polite "yes", no matter what your 'guinea pig' actually thinks. A more telling way of gauging the effectiveness of your style is to ask, "What do you think the person in this picture is feeling?".

Here's a transformation effect (*below*) that works by showing each stage of the change simultaneously.

Here's a thought balloon special effect (*above*) which not only shows us what the character is dreaming but actually illustrates it as well!

Artist's Tip

Don't let what you think you can or can't draw limit your story ideas. No matter what you need to draw, every object can be broken down into simple shapes!

Specialist special effects

Even beginner readers should be able to work out that diagonal lines slashed across a picture indicate driving rain or sleet, but unless you have seen the 'dotted line' method of indicating invisibility used in another comic strip it might not be clear from the picture alone exactly what is going on. In fact, you could be forgiven for thinking that the artist is using a faulty pen. If you're unsure whether the visual image alone is getting your message across, for clarity it might be worth adding a reference to what's going on in one of the speech balloons as well.

A special visual language

When you are searching your comic collection for special effects you can use in your own work, bear in mind that precisely because comic strip art has a special visual language all of its own, not all effects will be understood by everybody.

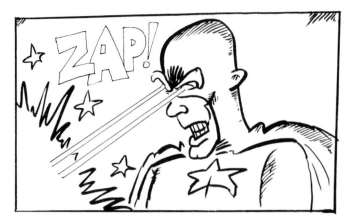

Comic books have always been full of mysterious rays, such as laser beams or 'power vision'. Make sure you put enough detail in your drawings to show up the white space and straight lines of your ray effects (*above*).

Here's a pretty shocking effect that should be familiar to fans of cat-and-mouse type cartoons.

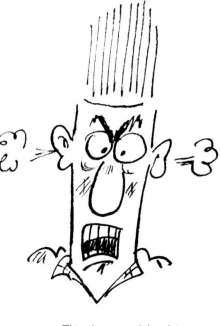

This character (*above*) is literally 'blowing his top'. How many well-known expressions can you turn into cartoon effects?

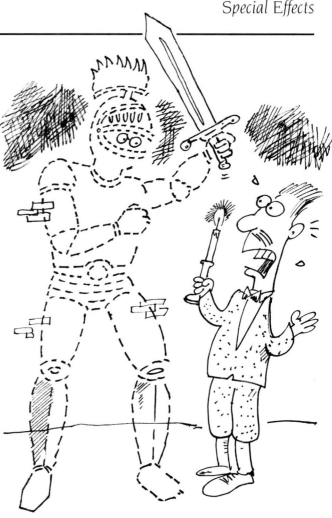

As the saying goes, two heads are better than one (*above*), especially if you want to draw someone looking rapidly from side to side doing a 'double take'.

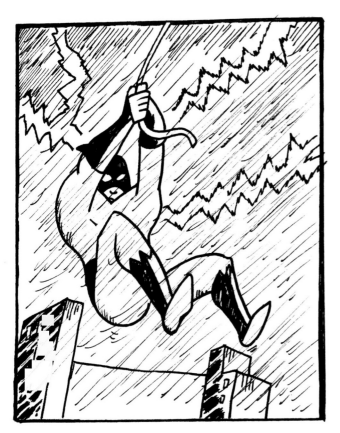

A dotted line (*above*) is standard cartoon shorthand for invisibility. It's simpler to draw the character in continuous line first and then, to achieve the effect, trace the dotted version over the top.

Whatever the weather – hail, rain or snow, your friendly neighbourhood super-hero is always on the job. Don't forget to draw the rain with a thin nib so you can still see him through the storm.

Artist's Tip

There are no rights or wrongs in cartooning. Look at enough comics and you'll find quite a few different ways of showing the same effect. If the classic 'dotted line' effect isn't good enough for your drawings, try inventing your own way of depicting invisibility.

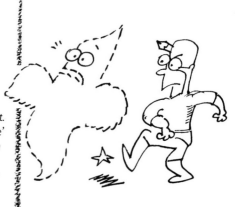

Creating a Grid

By now it should be clear that almost anything can happen in a comic strip story. Of course, everything that does happen has to happen within the confines of the basic comic page, and that's why creating a grid beforehand makes life so much easier.

If you're like me and straight lines are your least favourite artistic elements, you might feel that having to work with a ruler is closer to maths homework than creative expression. Believe me, the short time you spend drawing up your grid will allow you a lot more freedom when it comes to telling your comic story. Whether you're using many regular-shaped panels, throwing in a couple of 'widescreen' or special-effects type pictures, or even dispensing with panel outlines altogether, basing all your pages on the same grid will ensure that the story as a whole hangs together visually. It will also ensure that you don't forget vital details – such as page numbers – and, most importantly, that you don't run out of space just before your dramatic closing scene (or, worse, have a whole lot of blank space left AFTER your story has ended).

You can draw up your grid using the model provided on the opposite page, adjusting the size to suit your requirements. Alternatively, you could design your own grid completely from scratch. The grid can be used as a guideline for your artwork, and reused for each page.

When you have your grid, lay a sheet of drawing paper over it and map out the shapes for each frame of your story.

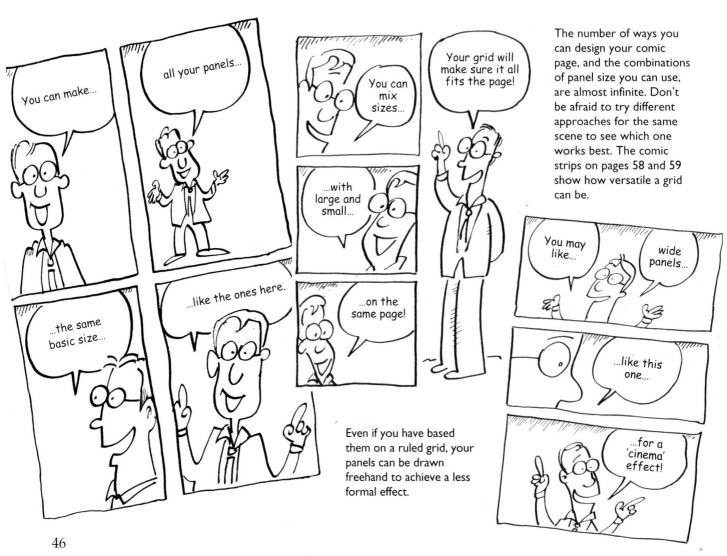

The number of ways you can design your comic page, and the combinations of panel size you can use, are almost infinite. Don't be afraid to try different approaches for the same scene to see which one works best. The comic strips on pages 58 and 59 show how versatile a grid can be.

Even if you have based them on a ruled grid, your panels can be drawn freehand to achieve a less formal effect.

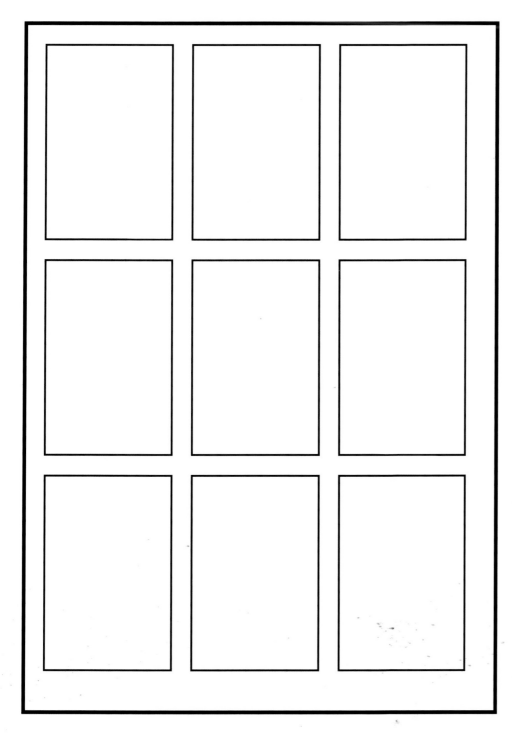

The grid shown above is based on a reduction of an A4 page. It represents a single, right-hand page. The top margin and the left (inside) margin are smaller than the right (outside) margin and the bottom margin. This will make the double-page spread look balanced when the left-hand and right-hand pages are seen facing each other. You can use some of this margin space and the space between the panels to incorporate jagged edges or other special effects in your strip. Don't forget that the panels can be joined or split up to vary their size.

Creating Time

Throughout this book we have observed the ways in which comic strip storytelling is similar to movies and TV. But there is one thing that the comics medium can do even better than moving pictures, and that is to play with time itself. Speeding up time, slowing down time, freezing a moment or object, even showing several things happening at once – all these things are possible in a comic strip with creative use of the grid. As well as being a useful story-telling device, being able to stretch out or condense actions or periods of time can come in handy when you are trying to make sure that your comic story exactly fits the number of pages you have available to tell it in.

Of course, like any 'box of tricks' it is possible to spoil the effect you are trying to create with these techniques – for example, by using too many of them at once or using a number of them one after the other. Even the best device can lose its novelty value. Practise some of the 'time' effects on these pages and you'll be able to use them in your own strips appropriately.

Another job for our hero (*below left*) but how fast he gets there depends on how much space you have and how you want to tell the story. We don't need to see him flying to the scene of the crime (*below right*) ... on the other hand, this extra panel (*below centre*) might be ideal for showing that he's missing his dinner.

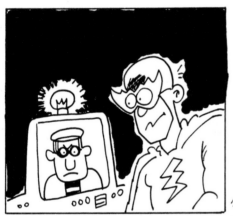 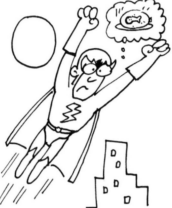 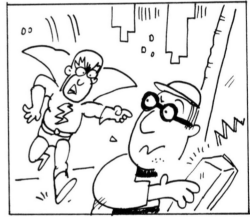

Keep experimenting with your panel arrangements to see what effects you can achieve. Here's how to show the inside and outside of a spaceship in the same time frame. This approach is particularly useful in science fiction stories where there is a danger of the reactions of the characters being upstaged by the hardware.

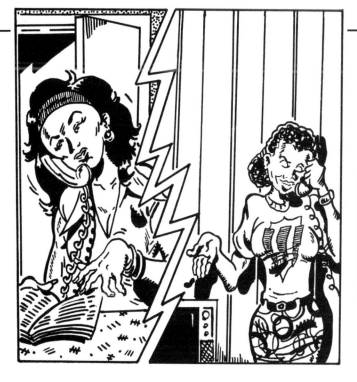

This design (*above*) allows you to show two things happening at once. Note that the two characters are holding their phones in their own individual ways.

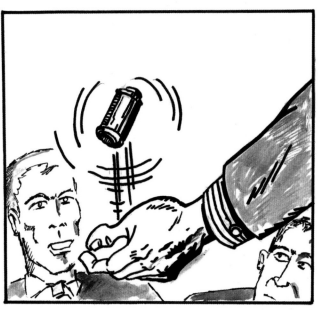

You can emphasize the significance of vital story elements – such as the film canister in this frame (*above*) – by 'freezing' them in mid air.

Leaving out scenes can speed up the action. Here's a way to slow things down – by stretching the progress of this lumbering beast across three panels.

Story and Script

Although this is primarily a book about the drawing aspect of comics, and there are several very successful comic artists who work only in pictures, you should be aware of the close linkage between words and images in this genre, for this is a unique aspect of comic strips in relation to other visual media.

In the world of professional comics there are two kinds of artist. Some of the best artists work from scripts and ideas that other people produce, allowing them to concentrate completely on the drawing side of the process. Other, equally successful, artists do both the writing and drawing, with very little input from anyone else.

Whether you are interested in writing full time or not, it is useful to attempt making up your own comic stories. Knowing something about the art of storytelling is important, even if you end up only drawing from other people's scripts. The printed word and the visual image are separate areas, and to turn a written story into pictures often involves minor changes and compromises that only an artist and writer working closely together can make.

THE ADVENTURES OF LIGHTNING MAN

Panel One:
It's evening – Sam Citizen leaves the newspaper office.

Dialogue:

Sam (thinks): Another day over and still nobody suspects I'm really LIGHTNING MAN

Panel Two:
A stranger is lurking in the shadows behind Sam.

Panel Three:
Sam's super sixth sense tells him about the stranger.

Dialogue:

Sam (thinks): Wait! My super sixth sense tells me I'm being followed!

Panel Four:
Sam rushes around a corner, the stranger gives chase.

Dialogue:

Sam: Let's see just how fast this stranger can run!

Stranger: Hey! Come back here! You know there's no escape!

Panel Five:
Sam changes into Lightning Man.

Dialogue:

Sam: Maybe not for Sam Citizen – but what about for Lightning Man?

Panel Six:
Lightning Man grabs the stranger in a powerful grip.

Dialogue:

Stranger: Hey! Let go!!

Lightning Man: Not until you answer some questions...

Panel Seven:
The stranger is Sam's Mum, complete with birthday cake, cards, balloons, etc.

Dialogue:

Sam: ...Sure, Mum, but do we have to go through this every birthday?

On these pages are my original script for a short comic strip (*above*) and the finished artwork (*opposite*) by Leonard Noel White.

Here are my comments after seeing Leonard's version of my script. How would you have put the story into pictures?

Panel 1
This picture has been drawn pretty much as I wrote in the script. As this is a parody type story, Sam Citizen has been drawn as the classic 'mild mannered' reporter type. His pin-striped suit enhances this impression. Note the reflections in the glass of the building to get that 'early evening getting darker' effect.

Panel 2
The trouble with a black and white comic strip is that sometimes a shadowy figure can get lost among the shadows, but comic strips are about words and pictures working together so I added the caption on top of Leonard's picture to make sure we spot Sam's stalker.

Panel 3
A close-up of Sam with a specially created lightning effect to show his sixth sense working. Note that the background has been dropped for this picture.

Panel 4
There's a lot to show in this picture, so the speech balloons overlap. Note that the larger speech balloon overlaps the smaller one. This helps to direct the reader to read the larger speech balloon first, followed by the smaller one. This links the sense of the dialogue in panel four to the words in panel five.

Panel 5
Comic strips, as we have noted before, are about exaggeration and being larger than life – why simply say something when you can SHOUT it?

Panels 6 and 7
There was no way to fit all the dialogue I'd written plus a full-length figure drawing into panel six. But I liked the way the artist had shown both figures while managing to avoid giving the stalker's identity away. I cut the speech so that what needed to be said could be contained in the last panel.

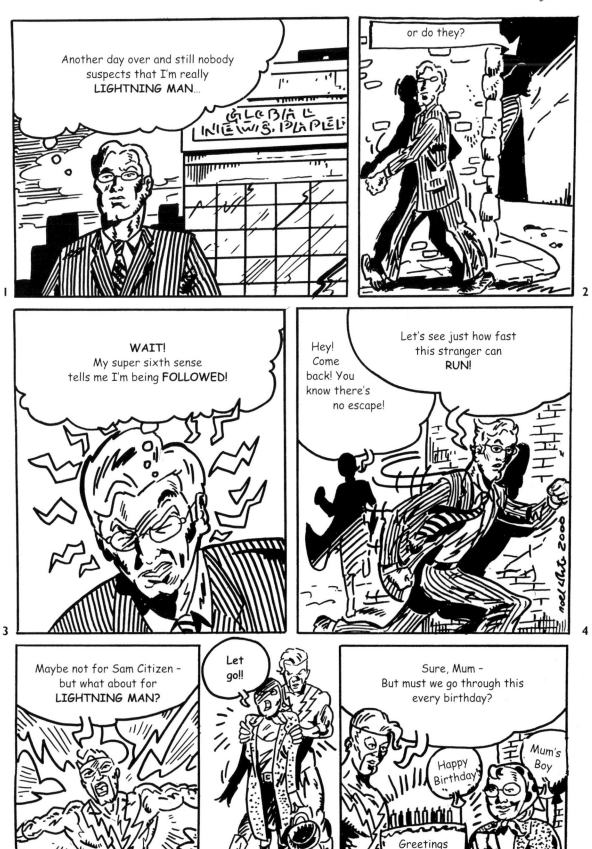

I hope it is clear from this book that while it presents the basic steps involved in putting together comic strip drawings, your drawings should not end up looking like John Byrne's, Leonard Noel White's or those of any other comic artist you care to name. That would be very disappointing. Just as you will develop your own individual style of drawing the more you practise, your writing and storytelling skills will also develop the more you use them.

Another similarity between creative writing and drawing is that the whole process is one of trial and error. At the outset you try developing an idea in a certain direction and if that doesn't work you go back to the beginning and develop it in an entirely different way. I have found that rather than attempting to get one perfect finished drawing or complete story down on paper in one go, it is better to play around with ideas until you tease out something that really works. Polishing up an idea from this point is

then relatively easy. You can come up with a comic strip story, funny or dramatic, long or short, simply by taking any situation or image and asking yourself, "What happened next?"

Artist's Tip

Here are three 'instant story' ideas on which you can practise your comic strip skills.

1 Take a well-known fairy tale and retell it in a modern setting.
2 Retell your most exciting/embarrassing/ frightening experience.
3 Take a dramatic story and retell it in a humorous way.

The strips shown below and at the top of the following page are my versions of the 'what happened next' technique.

Each stage of this drama can also be shown from a different visual pespective. For example, looking up at the action (*below*), looking

down, or viewing it in close up or from far away. Such decisions have a direct bearing on how a story is told and the type of impact

it achieves. They are central to the work of the comic strip artist, and you will find yourself making them all the time.

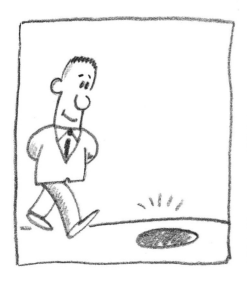
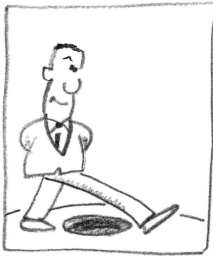
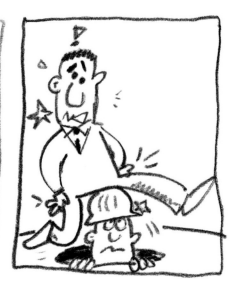

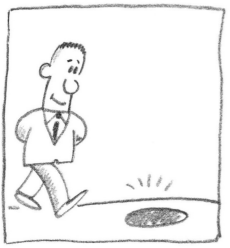 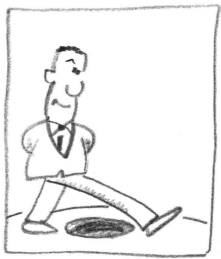 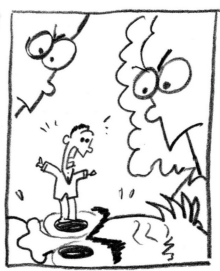

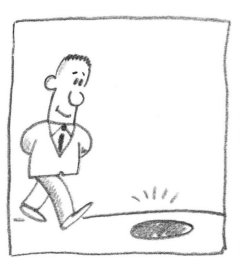 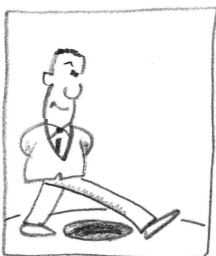 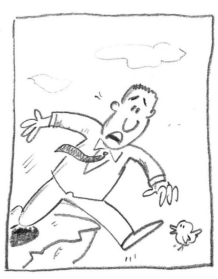

The previous strip depicts a fairly standard open manhole sight gag. For this second version (*above*) I've

used the same two pictures as previously to set up the joke, but opted for a surreal ending.

If you try as many different variations of your strip as you can come up with, you'll end up with something really interesting.

In the final panel (*above right*) I decided that the character would

unexpectedly leap into a void. Now create your own ending for this strip or alternatively expand it into a complete story.

Start by roughing out different viewpoints. This will help you to find the

best way to develop the story and work towards a suitable funny or dramatic ending.

Don't worry if you do not manage to complete two wholly different versions as I have done.

Developing Roughs

Now that we've looked at everything that goes into making a comic strip page, it's time to put them all together and use them to produce a finished strip. On these pages, I've broken down into individual stages the way I would draw a humorous strip and a dramatic story. Before proceeding, though, it's worth pointing out once again that just as no two artists' drawing styles look completely alike, no two working methods are exactly the same either. There's no real 'right' or 'wrong' way to work – the only 'right' way is the way that works for you. And the only way to find that 'right' way is to try as many variations as possible.

Whichever kind of strip you're planning to draw – a short three-picture strip to appear in a newspaper or a 150-page 'graphic novel', whether you intend it to be humorous or just plain exciting, or whether you prefer to work with brush, pen or pencil – everything starts with a blank sheet of paper. It must also be said that for many artists, including professionals, everything sometimes ends with a blank sheet of paper, too – or at least looks as though it might, until you put in that extra bit of hard work.

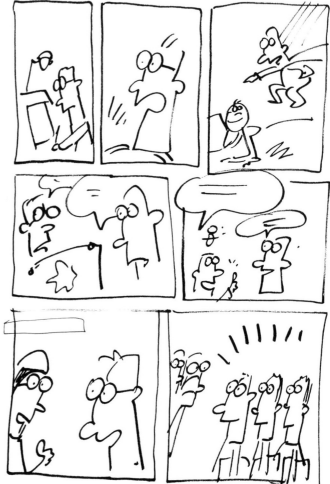

Here's my first rough version of the strip for which final ink drawings are shown on page 58. The basic joke is about the lengths to which we pros are sometimes driven to meet a deadline. My original (*above left*) was in danger of turning into a 'person gets stuck in the photocopier' gag. To avoid this I decided not to show the actual copier, so I could make the ending more of a surprise (*above right*).

That sinking feeling ...

The best way to turn this blank page into a good comic strip is not to worry about turning it into a good strip. The feeling of "what on earth shall I draw/write today" will be familiar to many, and this feeling is all the more scary if there's a pressing deadline. You're not under this pressure – yet – so don't pile it on unnecessarily. At the outset simply concentrate on making the page less blank. The 'rough' stage is when you can play with ideas, experiment with story lines, approaches and, if you're lucky, discover new ideas that you would have missed by going straight to finished artwork.

Artist's Tip

Hold on to your roughs – the idea you discard or change now may be just what you are looking for in a month or two!

Leonard Noel White's graphic strip shows a dramatic helicopter accident. When the artist had finished the first version, he felt there was too much 'hardware' on show (*below left*). The developed version increases the drama by putting the emphasis more on the people involved (*below right*).

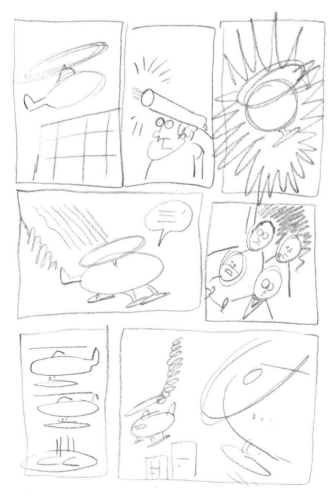

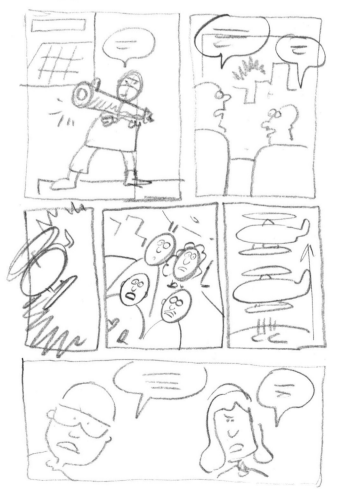

Final Pencil Drawing

It's a simple point but well worth repeating that every kind of drawing medium has its own strengths and weaknesses. As I pointed out at the beginning of this book, you can do your comic strips in whatever medium suits them best or suits the particular style or characters you are trying to develop. Commonly, comic strip artists produce a finished drawing in pencil and then go over it in ink to assist reproduction – this is the kind of 'finished pencil drawings' we are referring to on these pages. That said, there is absolutely no reason why you shouldn't do your strip entirely in pencil (not to mention poster paint, pastel or mascara, if you so desire!).

One of my main aims when I'm taking a cartoon or comic strip from a 'rough' through finished pencil stage to the final ink version is to keep the energy of the original idea. While it's important to pay attention to detail, it's the energy and humour of silly ideas (as here) that give them their appeal. Try to keep that feeling in mind while you're drawing.

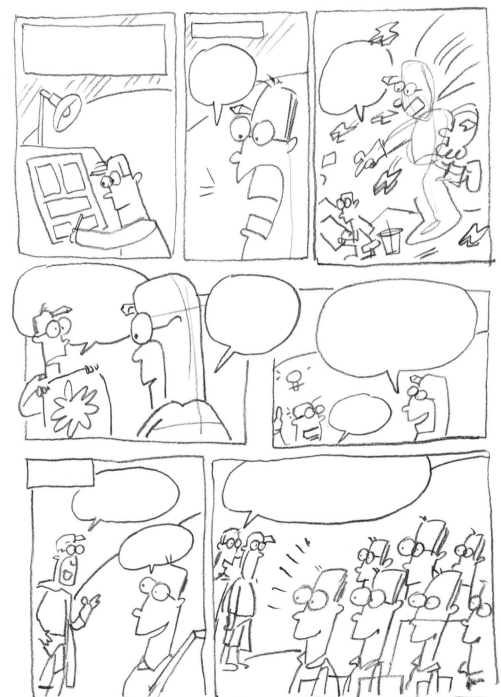

If your panel area is small and you're worried about getting proportions right, draw full figures at pencil stage and later rub out the bits you don't want.

Other media

If you are planning to use another medium to finish off, bear in mind that some of the qualities of your pencil version – for instance, pencil's ability to give different weights of line and shades of grey depending on how hard you press – may not be evident in the finished version. You must aim to create a solid framework on top of which you can do your final inking job. It's advisable to take advantage of pencil's ability to be corrected relatively easily to iron out any late problems or mistakes so that you can approach the ink stage with a confident line that will make your strip distinctive.

Artist's Tip

To stop your pencil strokes smudging while you're going over your drawings, it's a good idea to keep a small piece of paper or card under your drawing hand.

To maintain energy in action strips, I like to work through the page in 'sweeps', first putting in my light guidelines for each panel, then doing the basic drawings, then the fine details, building up to the finished pencil stage. Other artists may prefer to complete each panel before moving on – either way, your grid keeps everything in its place.

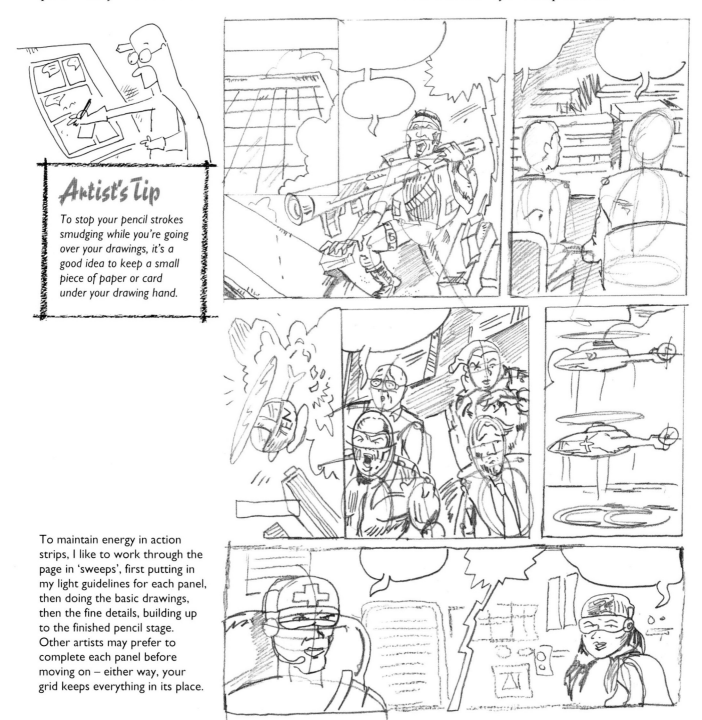

Final Ink Drawing

By the time you have worked through the rough and finished pencil stages of your artwork, you should be pretty sure of the finished result you want to achieve. Don't feel you have to slavishly go over each line of your pencil drawing in ink – if you do this you may well end up with a flat and lifeless drawing. Treat the pencil drawing as a guide for your inked drawing. Don't be afraid to add variations and details or, conversely, to drop details. Do whatever you think will produce a more striking overall image and your finished page will have a liveliness and sparkle all of its own, rather than seeming like a copy of a copy of a copy.

In this strip there's little or no background, so I've used some solid blacks to give the impression of shadow and also to make sure the main characters stand out. Note that I traced the figure in the last panel over and over again, to make sure that it really was identical. (To see how the idea for this strip started out, see pages 54 and 56.)

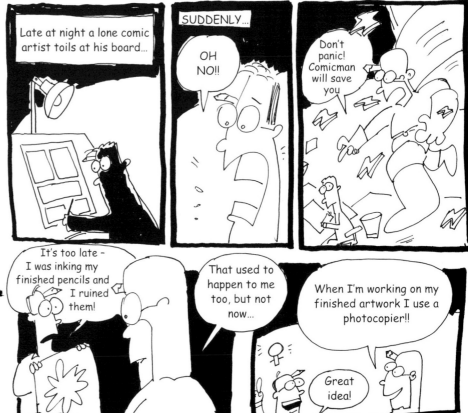

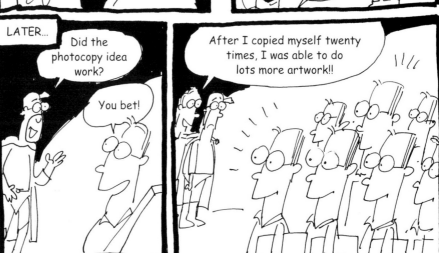

Artist's Tip

Finally, don't forget to do a quick check of your finished artwork for any errors that may have crept in and need to be corrected. Although most of these should have been caught at the rough or pencil stage, the nature of more detailed work is that we often focus so intensely on small things that we lose sight of the bigger picture. I have seen an artist work for hours to get just the right 'metallic' effect while lettering the title page of a futuristic science fiction comic, only to discover that while the letters looked wonderful, the title was spelt incorrectly.

Hedging your bets

It goes without saying that when you ink your pencil drawing it's pretty hard to go back to the original if the results aren't what you wanted. It's a good idea to photocopy your pencil artwork several times to give yourself at least a couple of chances to get the inks just right.

It's a good idea to ink the strip in outline first before adding the black areas or cross-hatched shading, so you can get the balance right. If you use too little black the strip won't hang together, but if you apply too much you could end up making the whole thing look murky and detracting from the drama.

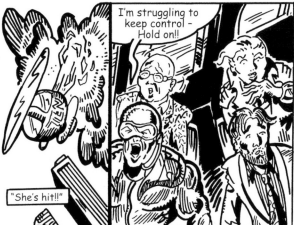

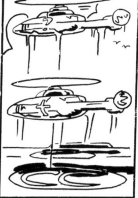

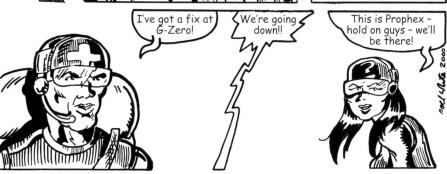

Although there's no set order for inking your strip, many artists like to ink in the lettering first to make sure it's legible and that no vital words are left out in the excitement of drawing. You can rub out the guidelines before inking the rest of the strip.

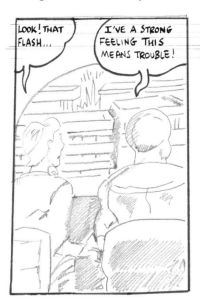

Using Reference

It's always amused me that one of the most prized skills artists have – at least to people who don't consider themselves to be good at art – is the ability to draw things 'out of their heads'. Comic strip artists certainly need to have this ability because so much of their work – from huge starships to talking chickens – involves illustrating figments of their imagination and not images from the real world. The reason I find the 'drawing out of your head' thing funny is that as a professional artist I'm aware that, amazing though the human brain is, it's virtually impossible to keep an accurate record of every thing you want to draw inside your head.

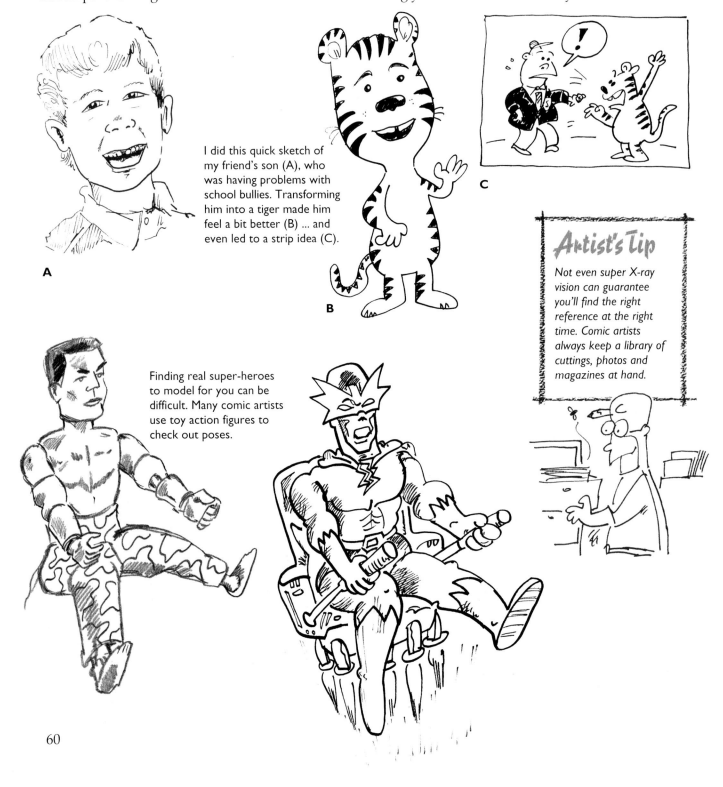

I did this quick sketch of my friend's son (A), who was having problems with school bullies. Transforming him into a tiger made him feel a bit better (B) ... and even led to a strip idea (C).

A

B

C

Artist's Tip

Not even super X-ray vision can guarantee you'll find the right reference at the right time. Comic artists always keep a library of cuttings, photos and magazines at hand.

Finding real super-heroes to model for you can be difficult. Many comic artists use toy action figures to check out poses.

Sourcing reference material

Most working artists, from fine art painters to fashion designers, rely heavily on reference material, life drawings and sketch books. Of course, it's a little easier to set up an arrangement of fruit in your studio or go and photograph your local high street than it is to find three armed alien giants to pose for you or a haunted castle to sketch. As well as realizing how useful reference material can be in improving the impact of your comic strips, you need to put your creative thinking to work on ways to make 'ordinary' references relevant to the world you are creating in your comic strips.

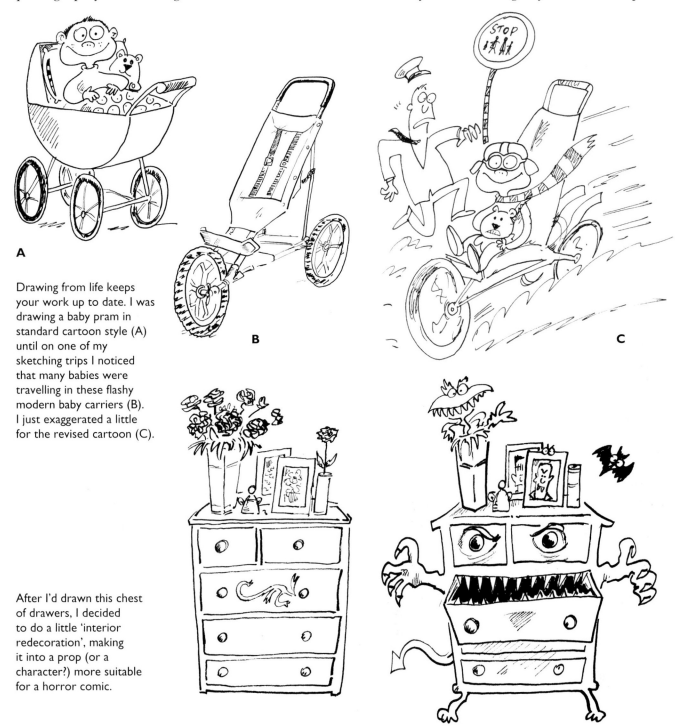

A

Drawing from life keeps your work up to date. I was drawing a baby pram in standard cartoon style (A) until on one of my sketching trips I noticed that many babies were travelling in these flashy modern baby carriers (B). I just exaggerated a little for the revised cartoon (C).

B

C

After I'd drawn this chest of drawers, I decided to do a little 'interior redecoration', making it into a prop (or a character?) more suitable for a horror comic.

Other Ways of Using Comic Strips

One of the biggest frustrations for comic strip artists is constantly having their work referred to as 'kid's stuff'. Not that there's anything wrong with children's comics – visual storytelling appeals to the child in all of us. However, I hope that by now in your research you have looked at enough comics and strips to realize how versatile and powerful they can be as vehicles for conveying messages, and not just in advertising. Comics can be just as effective when used for educational purposes or for getting across important public information.

Now that you have developed your skills, don't just limit yourself to drawing for comic books. Think about other ways in which you can put your new abilities to work. Whatever you decide to do with the opportunities ahead of you, happy writing and drawing, and good luck!

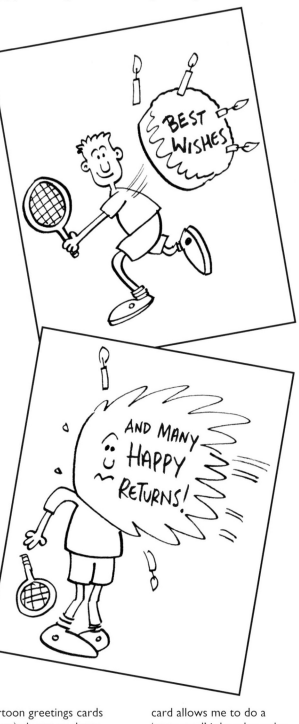

The comic-strip format can be used for educational purposes, as in this poster. Using three pictures means that the message is pretty clear even without the text.

Cartoon greetings cards (*above*) always go down well, especially when they are personalized. The fold-over design of this type of card allows me to do a 'two-panel' joke where the punchline doesn't become visible until the card is fully opened.

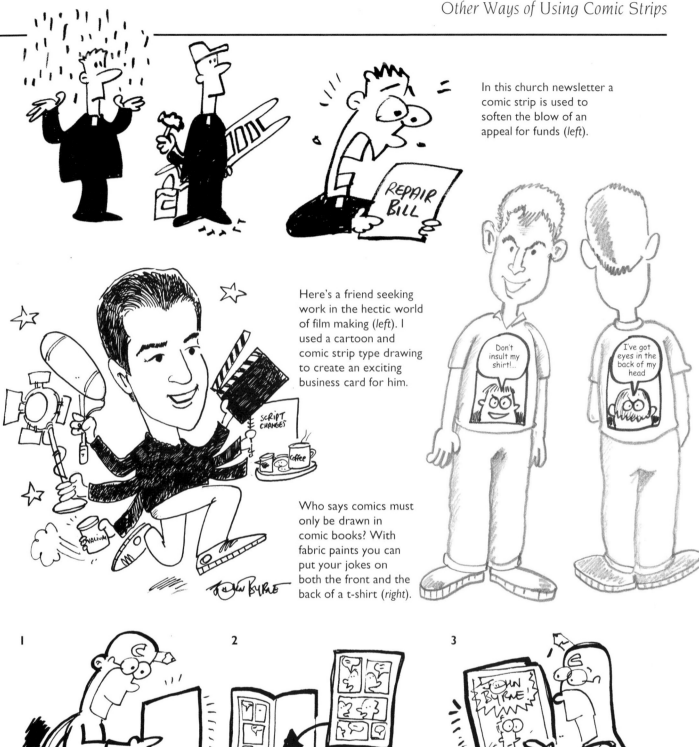

In this church newsletter a comic strip is used to soften the blow of an appeal for funds (*left*).

Here's a friend seeking work in the hectic world of film making (*left*). I used a cartoon and comic strip type drawing to create an exciting business card for him.

Who says comics must only be drawn in comic books? With fabric paints you can put your jokes on both the front and the back of a t-shirt (*right*).

Even if your aim is not to become a professional comic artist, it's still fun to be able to 'publish' your work.

1 Start by folding some blank sheets of paper into comic book size.
2 Photocopy each individual page of your comic art down to size and paste it into your comic.
3 A cover adds the finishing touch. You can use one big image or repeat a number of pictures from inside your comic to whet the appetite of your readers. (Now look overleaf at an idea for the comic cover for this book.)